PRESTON Potpourri

VOLUME ONE

Copyright © 2016 by Dennis Preston
All rights reserved
ISBN 978-1-365-43560-7

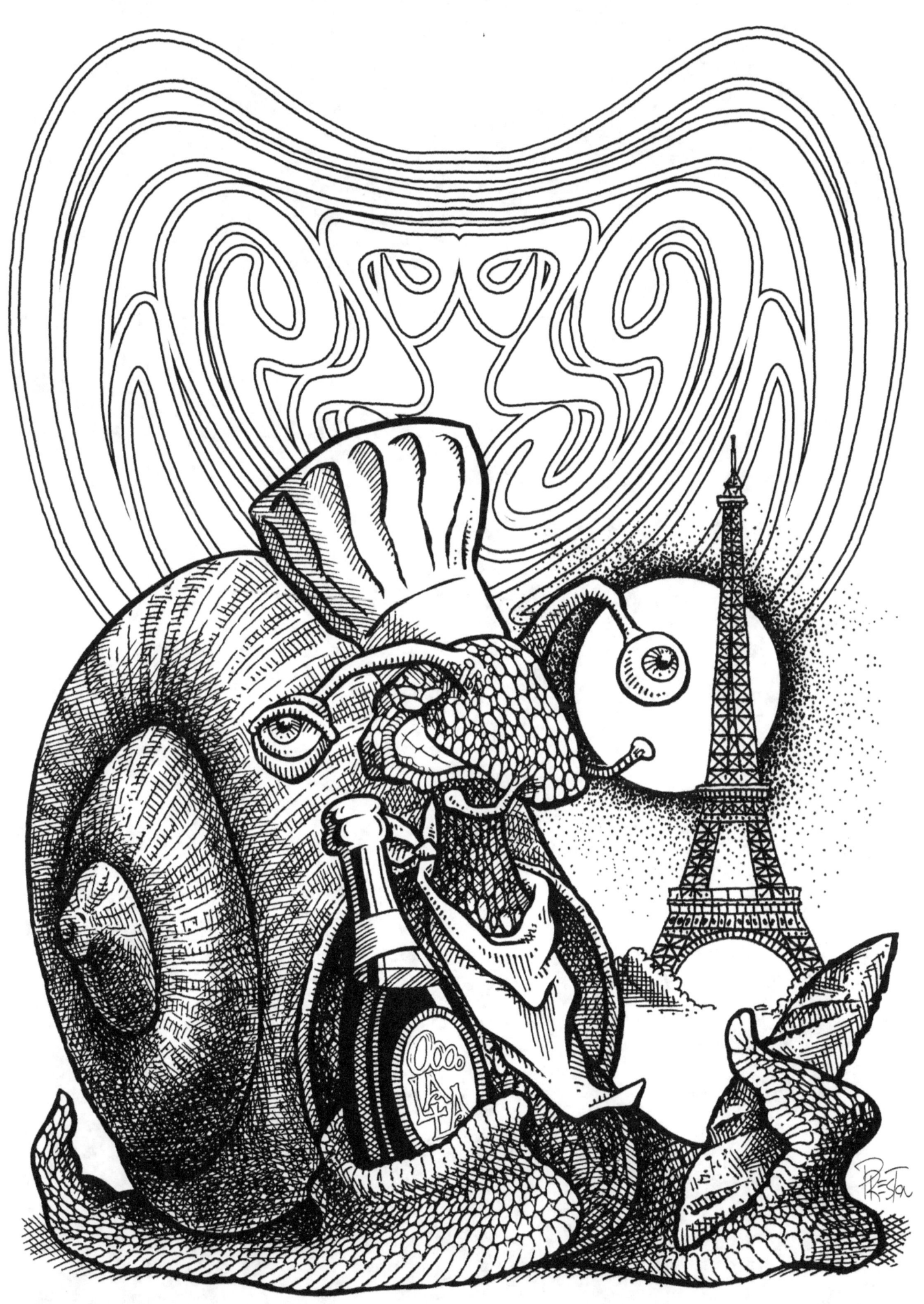

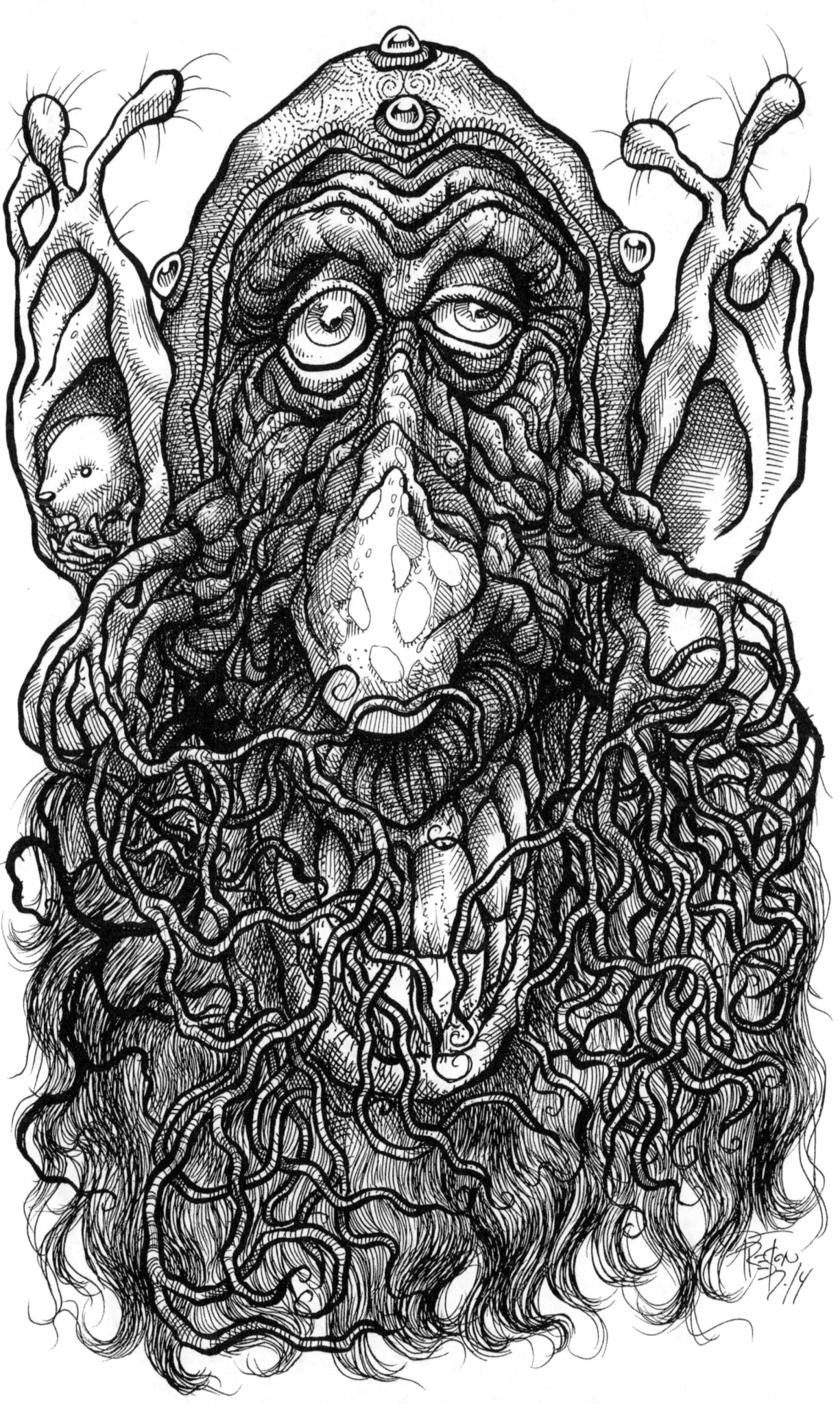

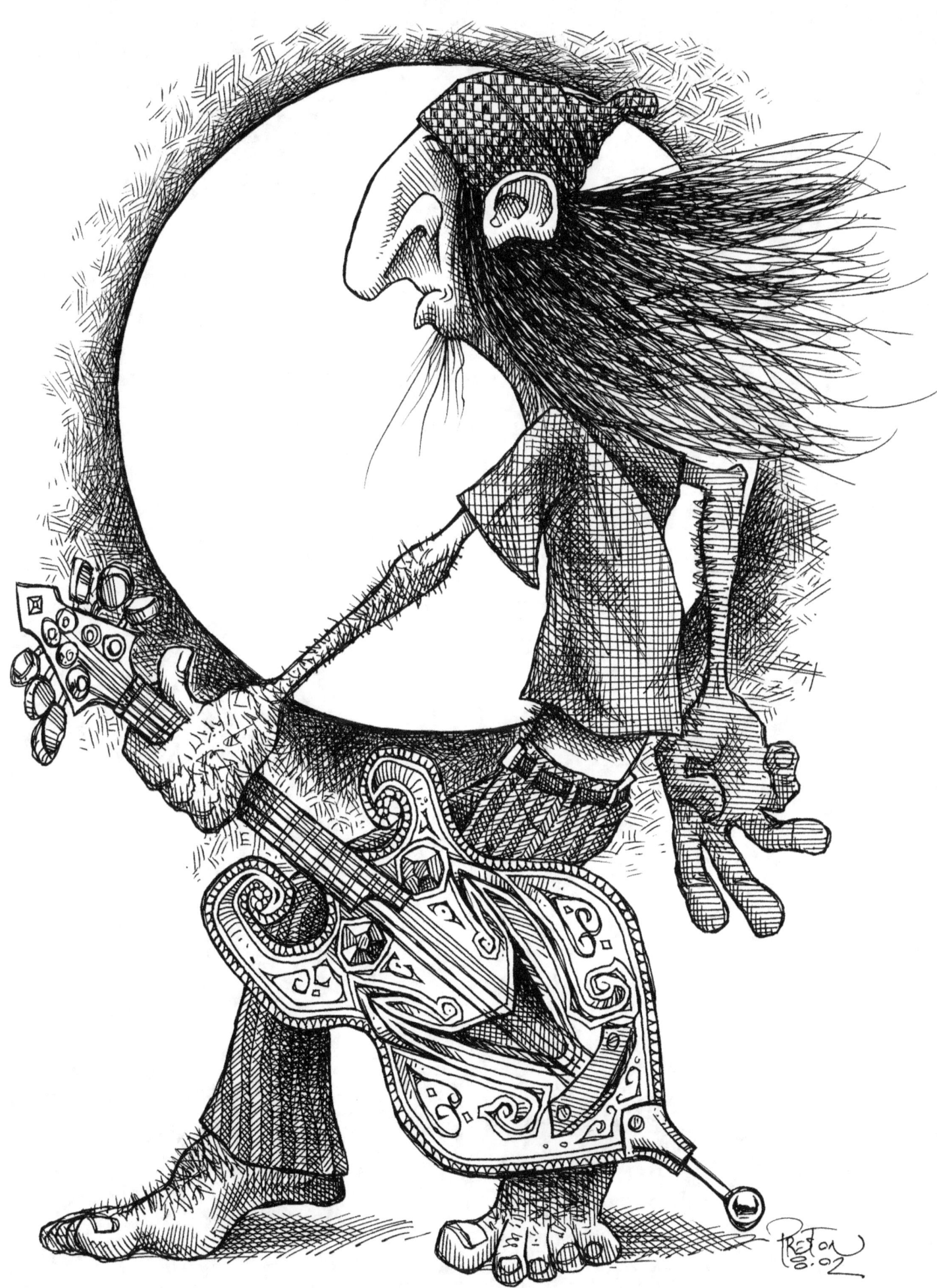

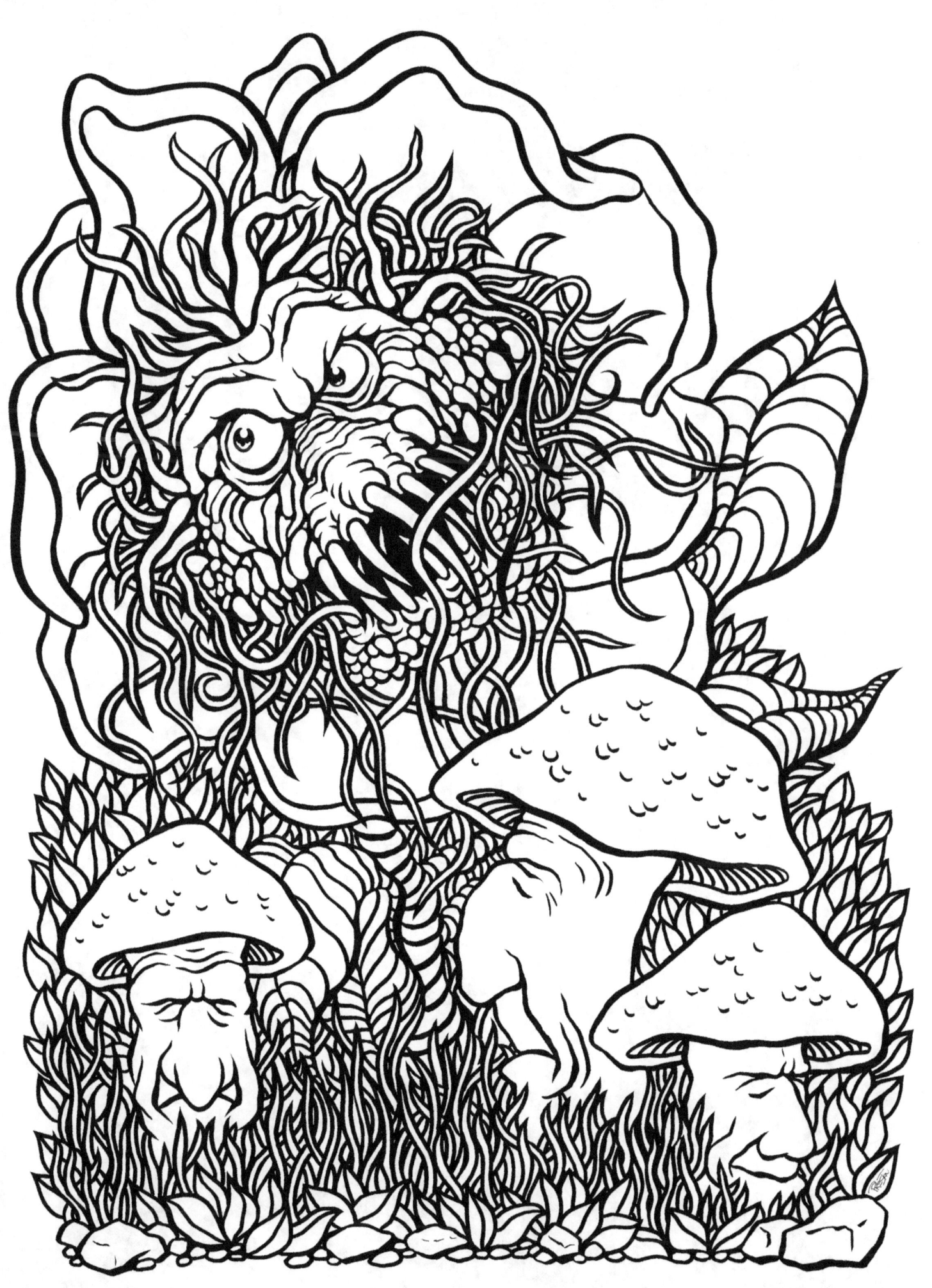

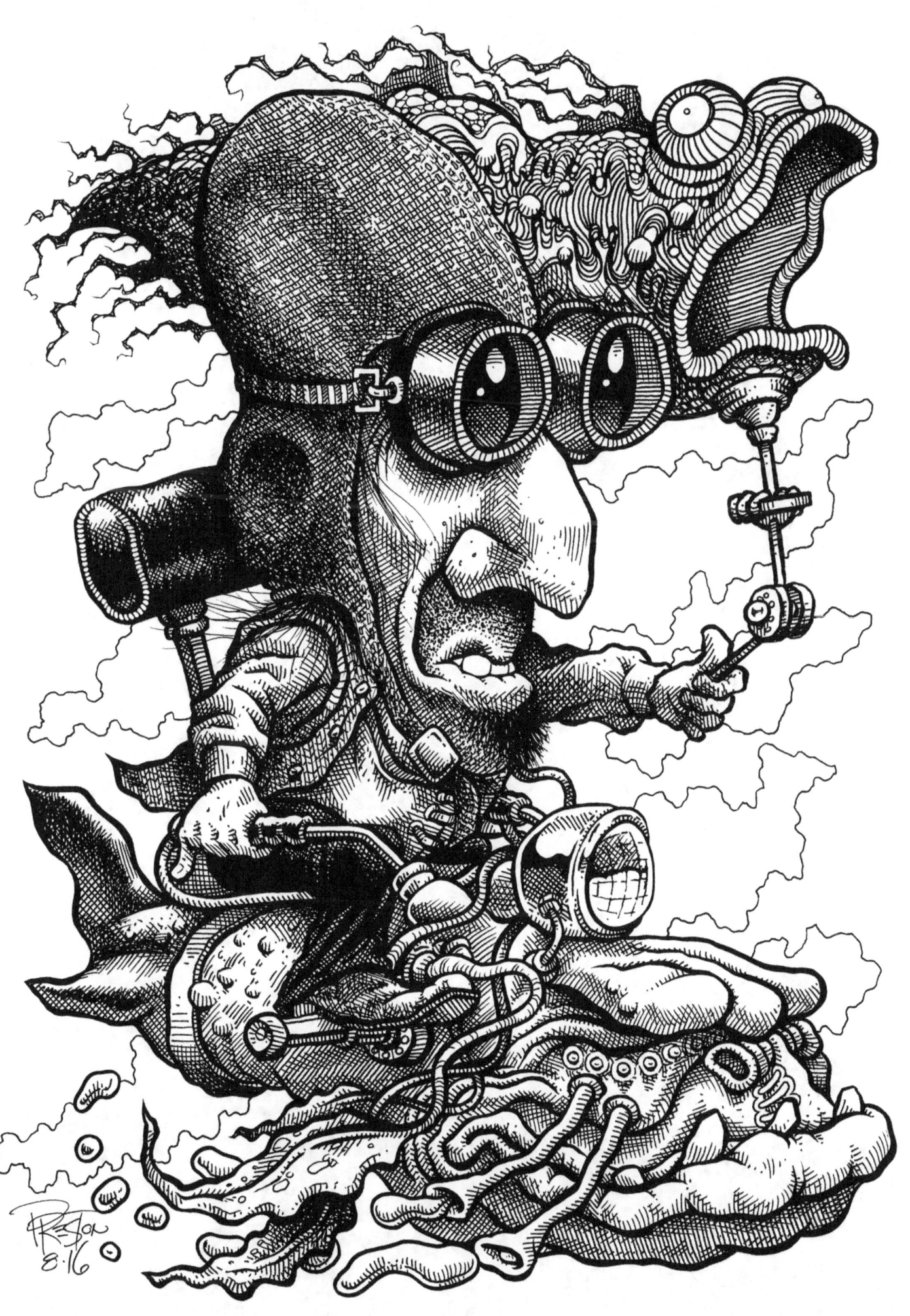

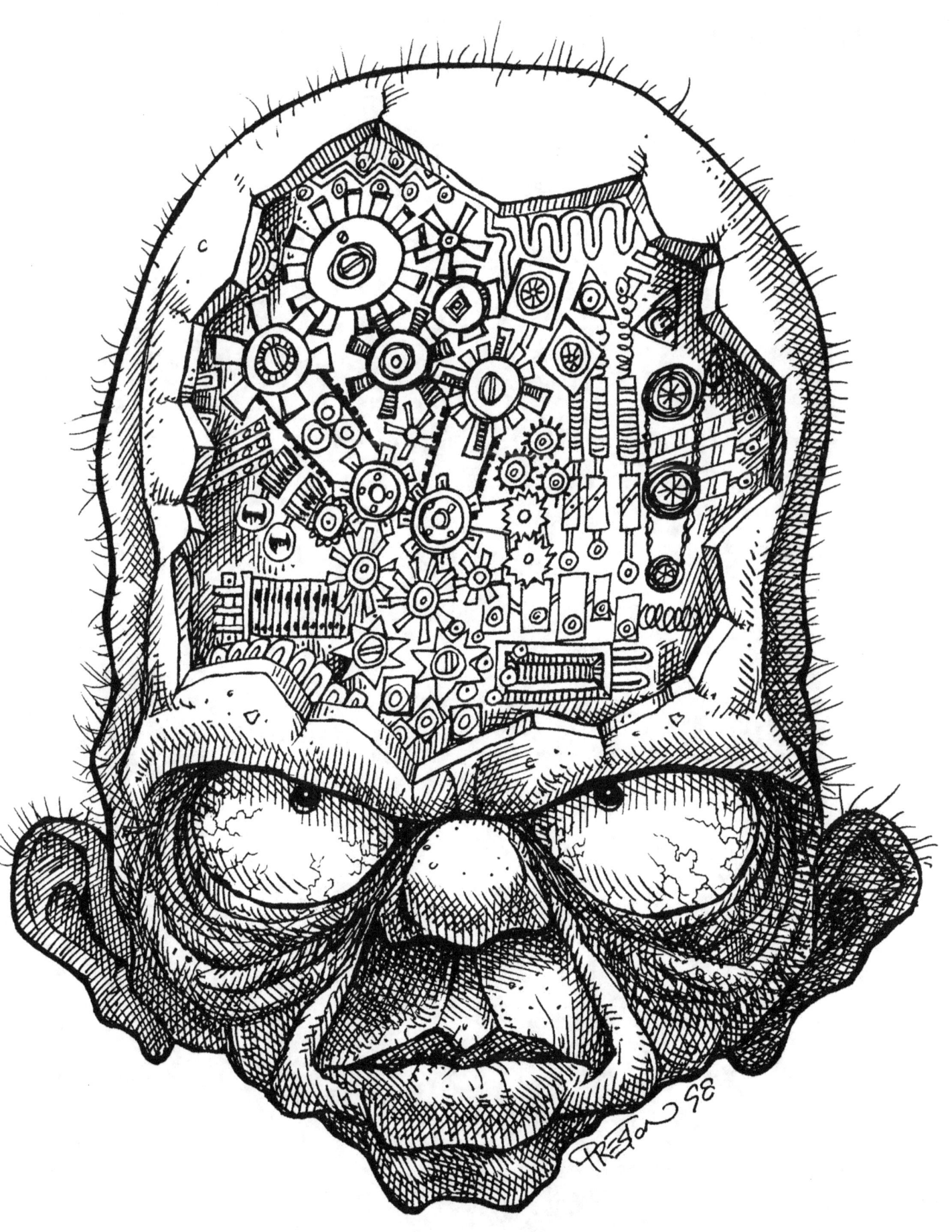

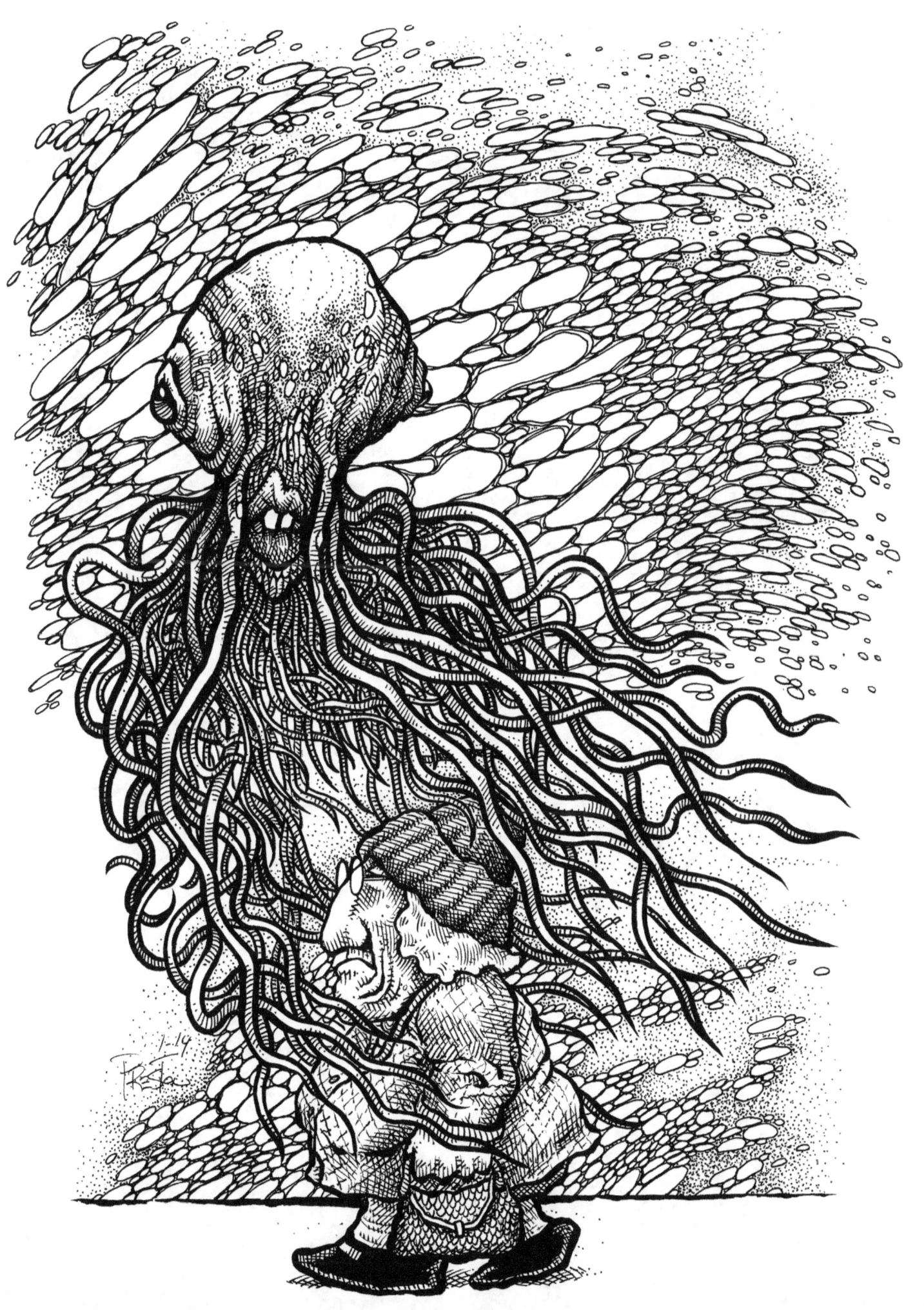

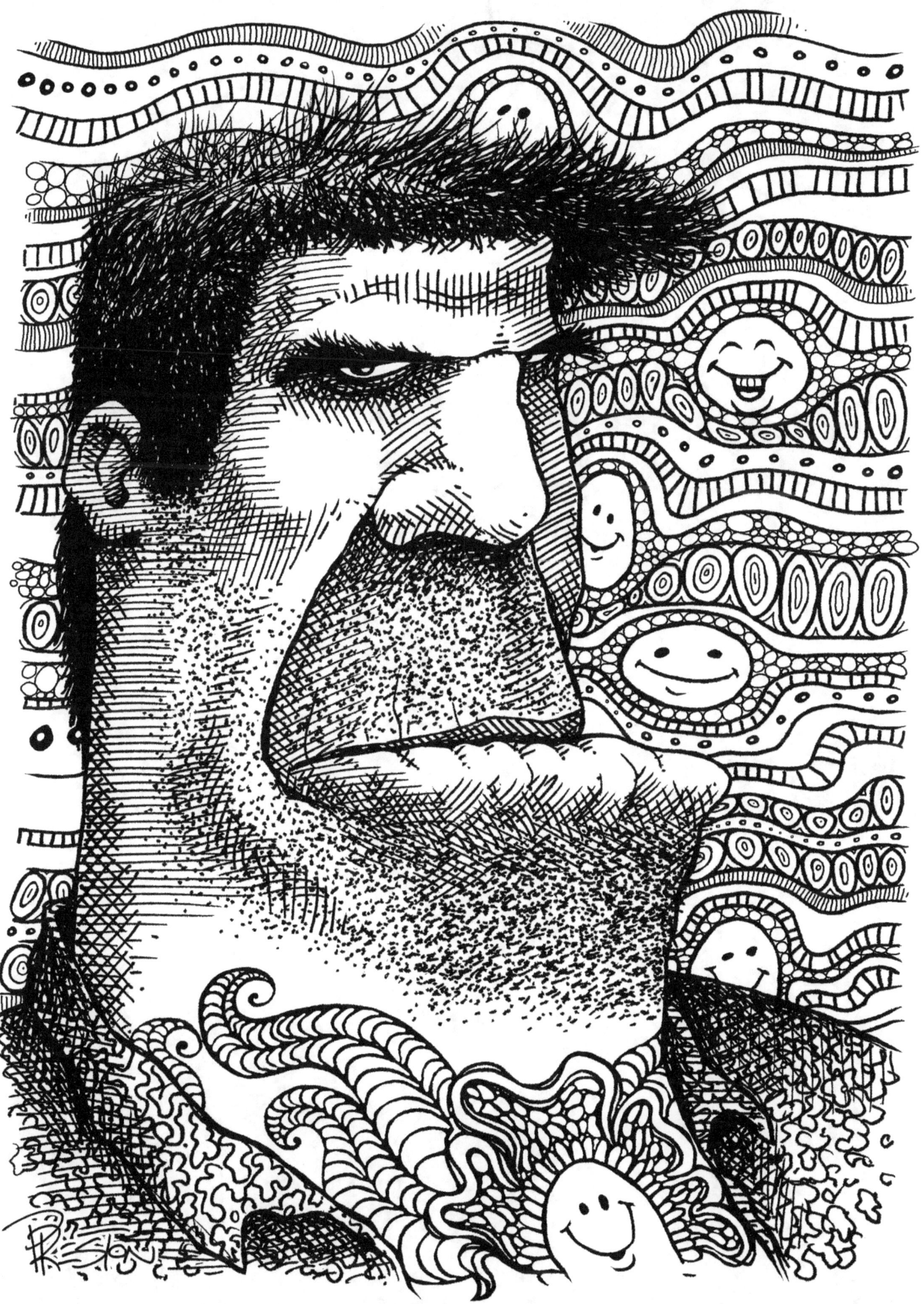

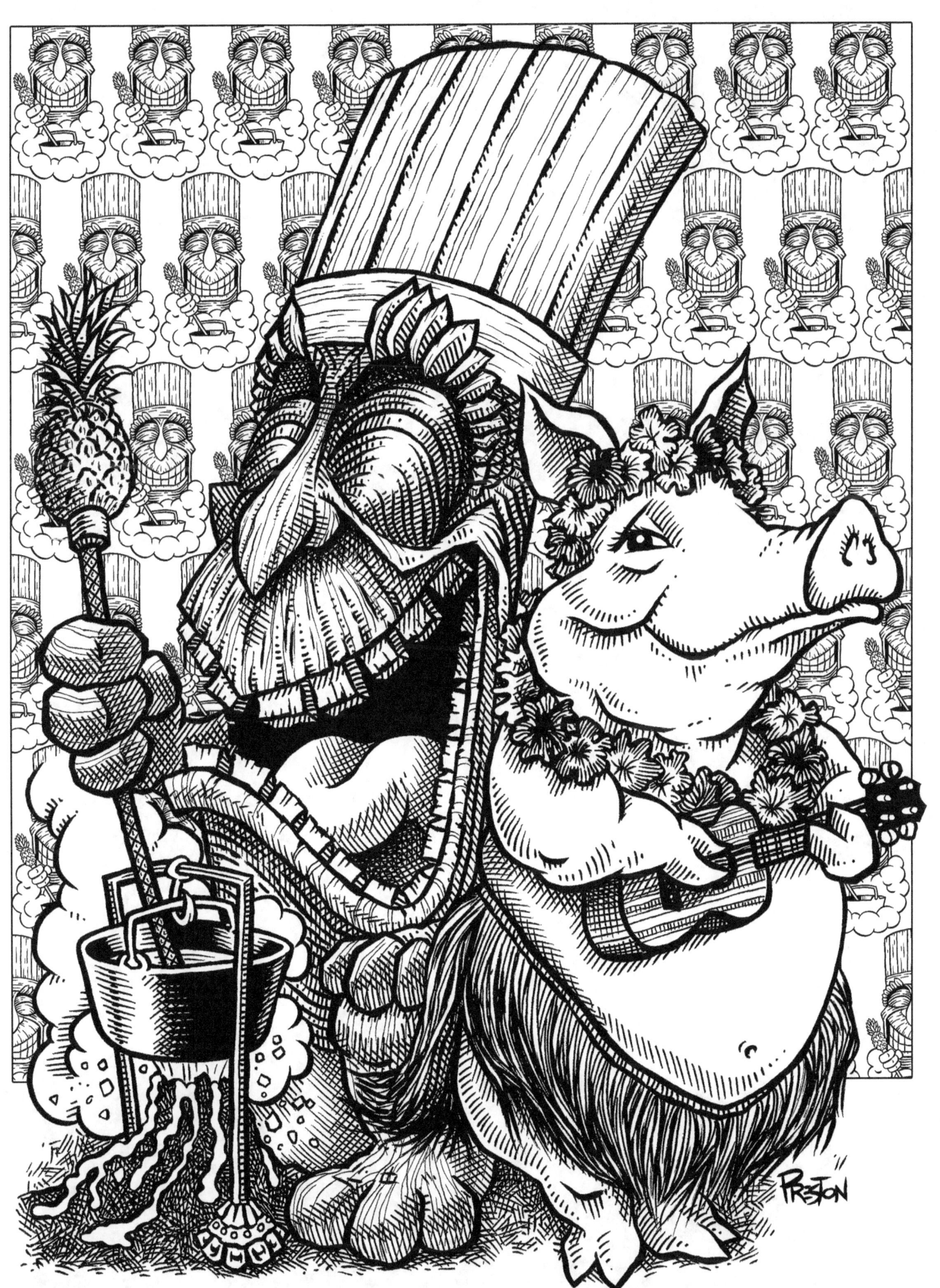

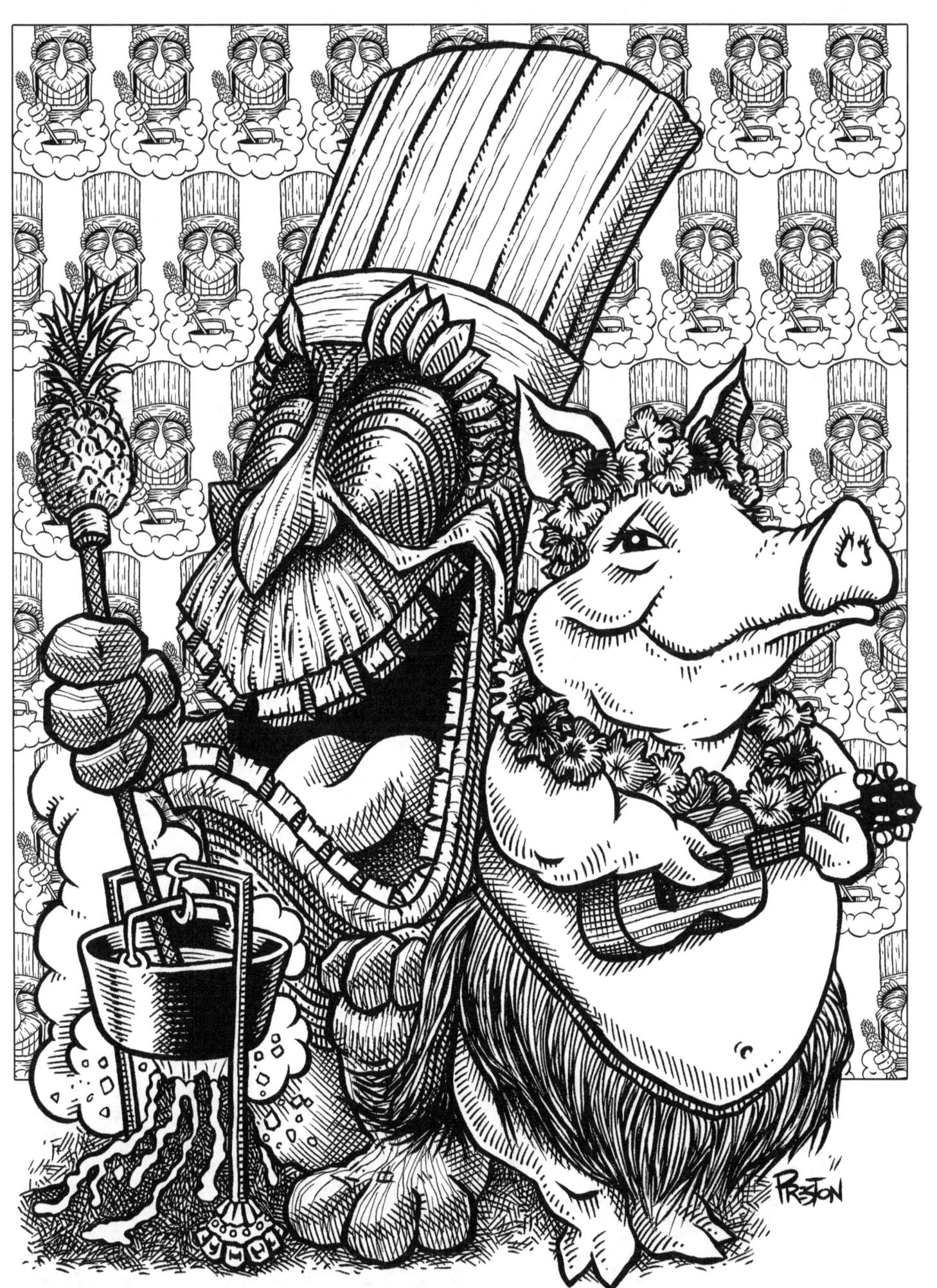

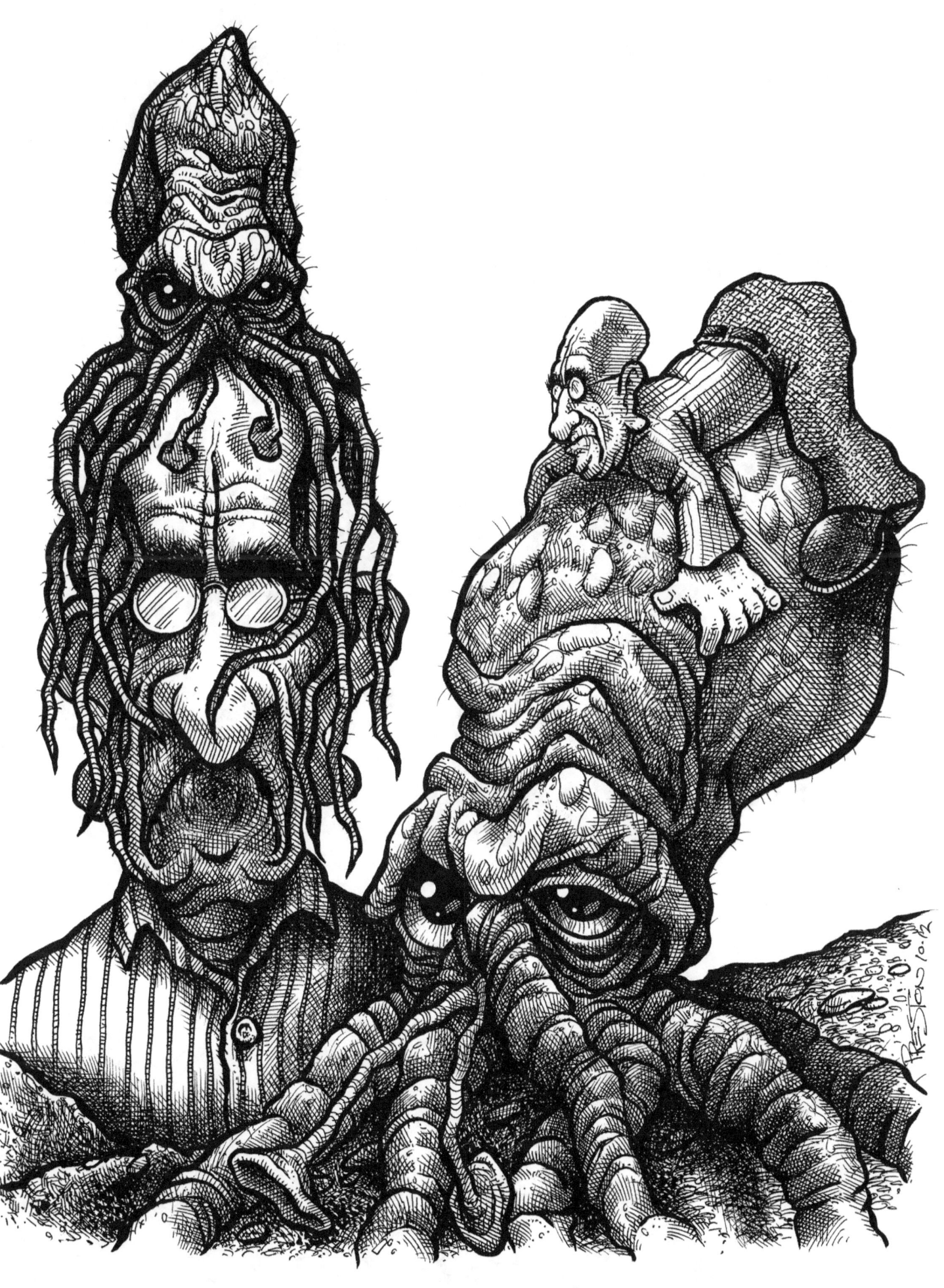

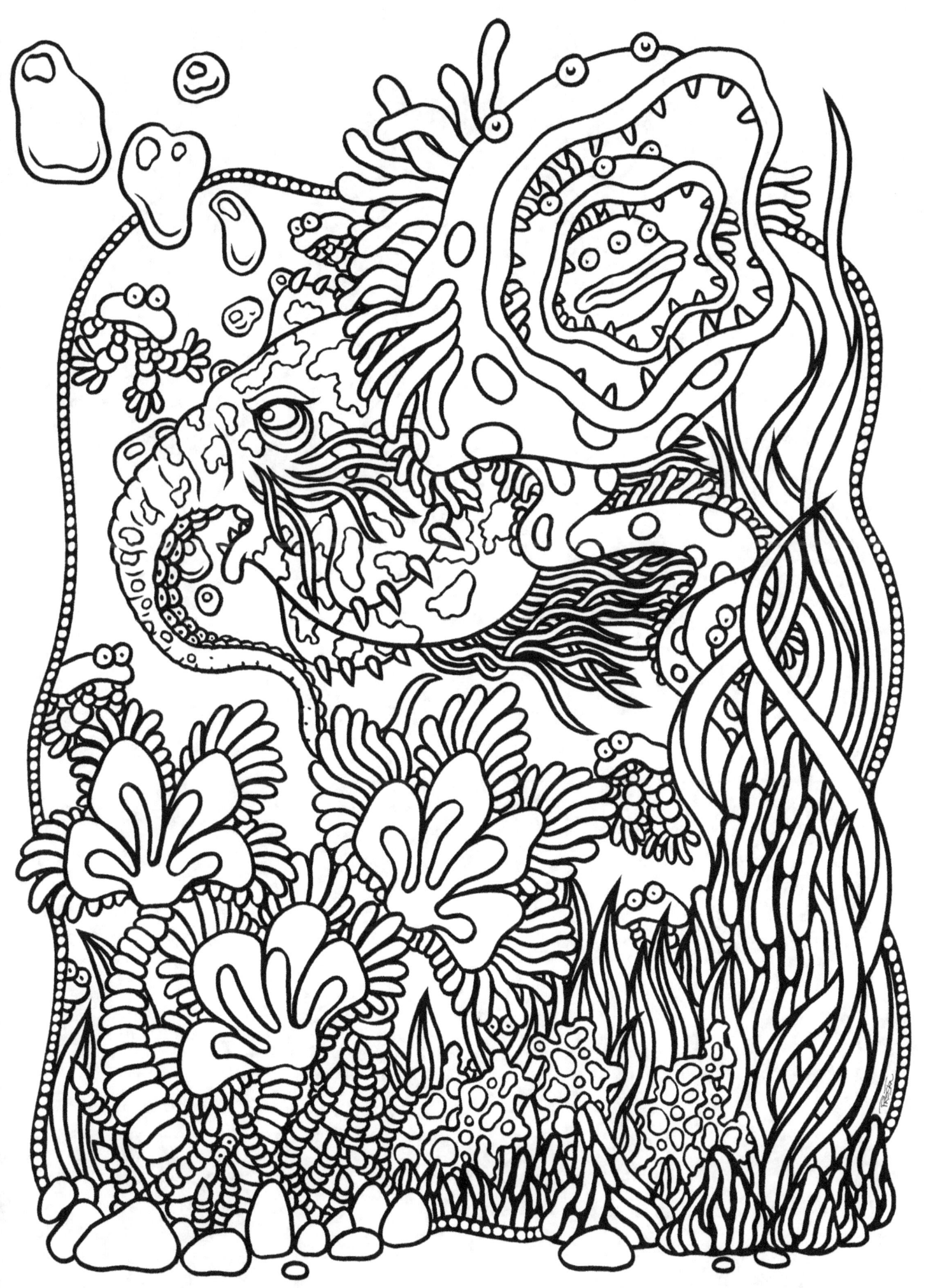

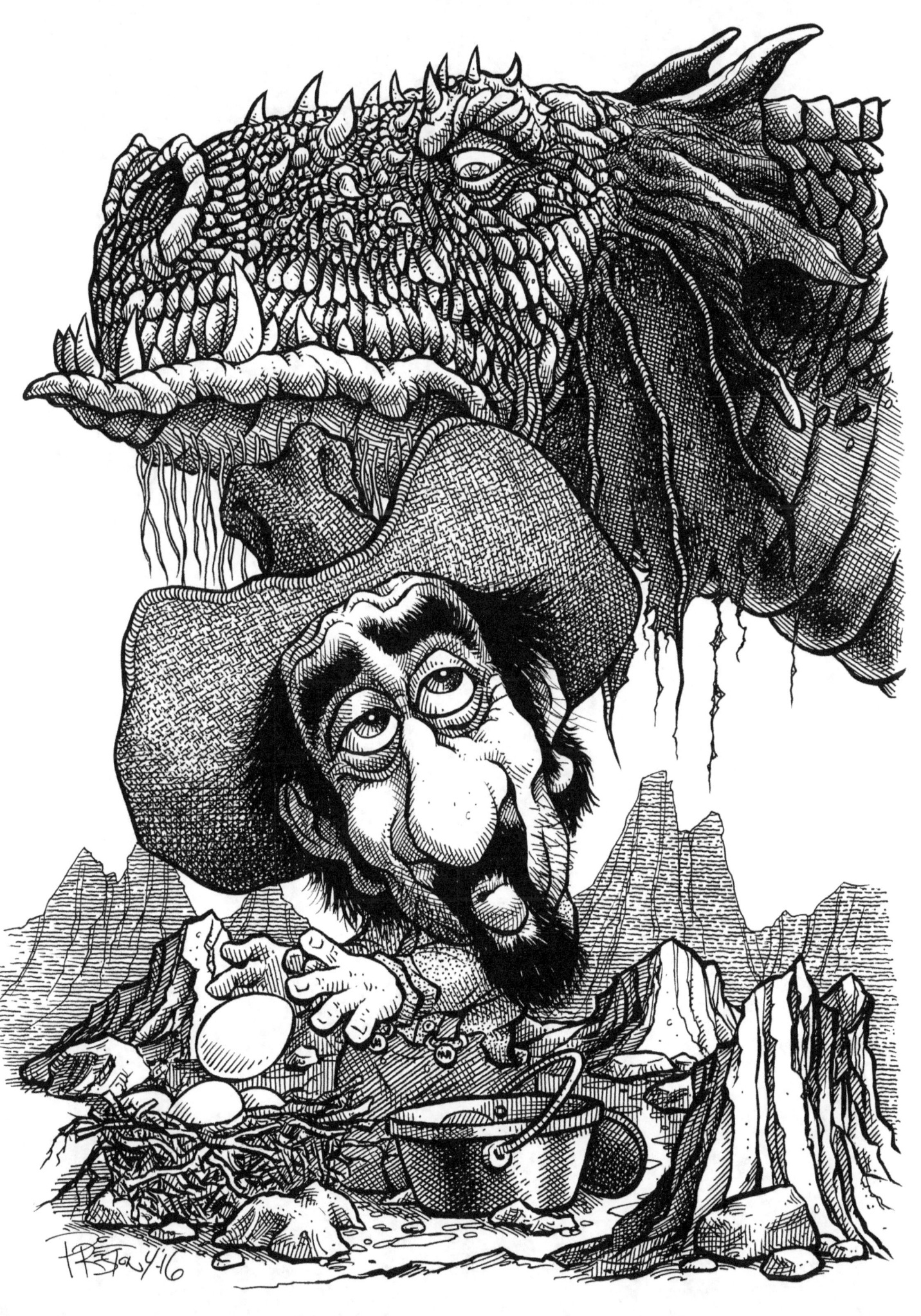

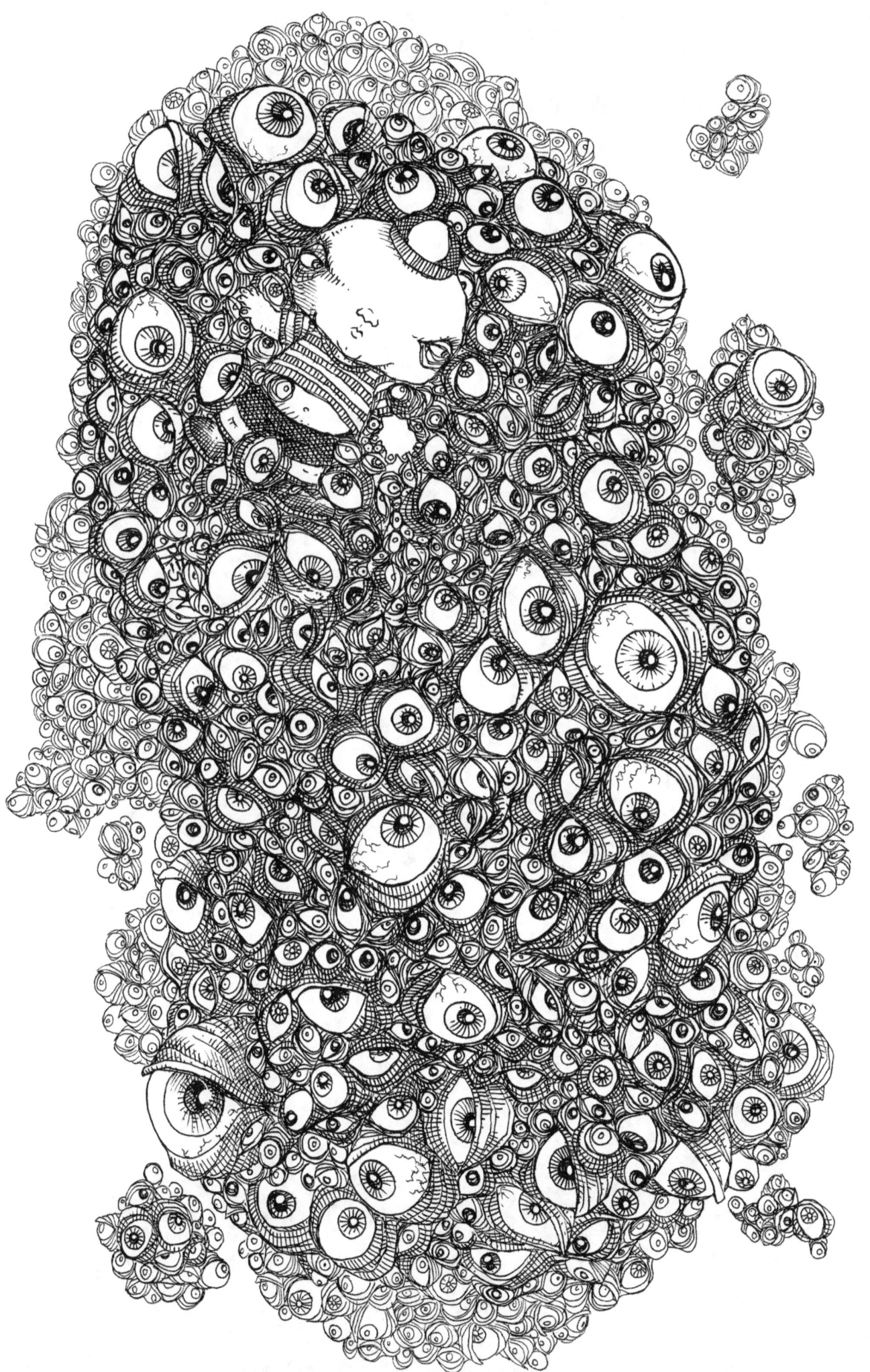

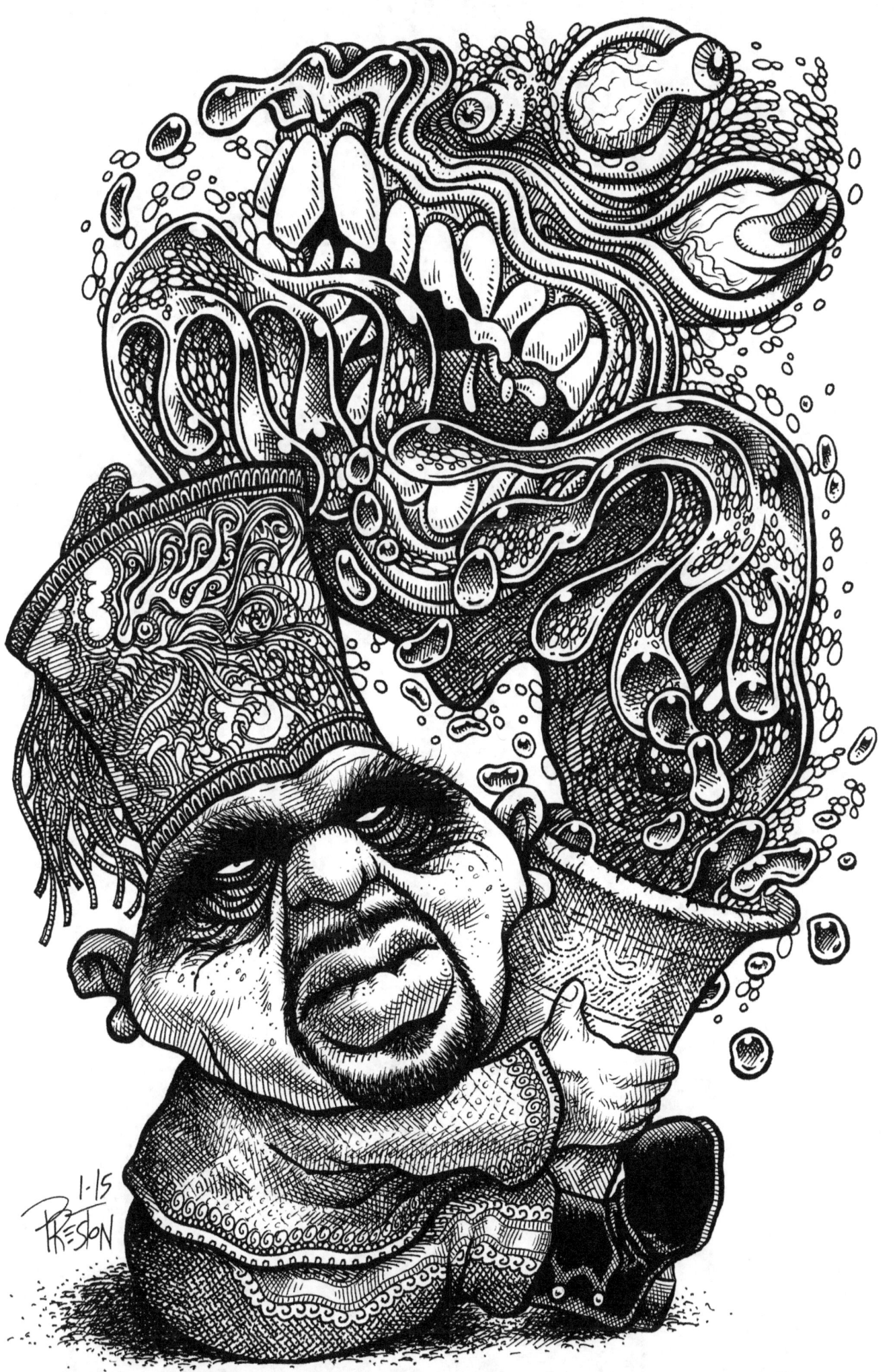

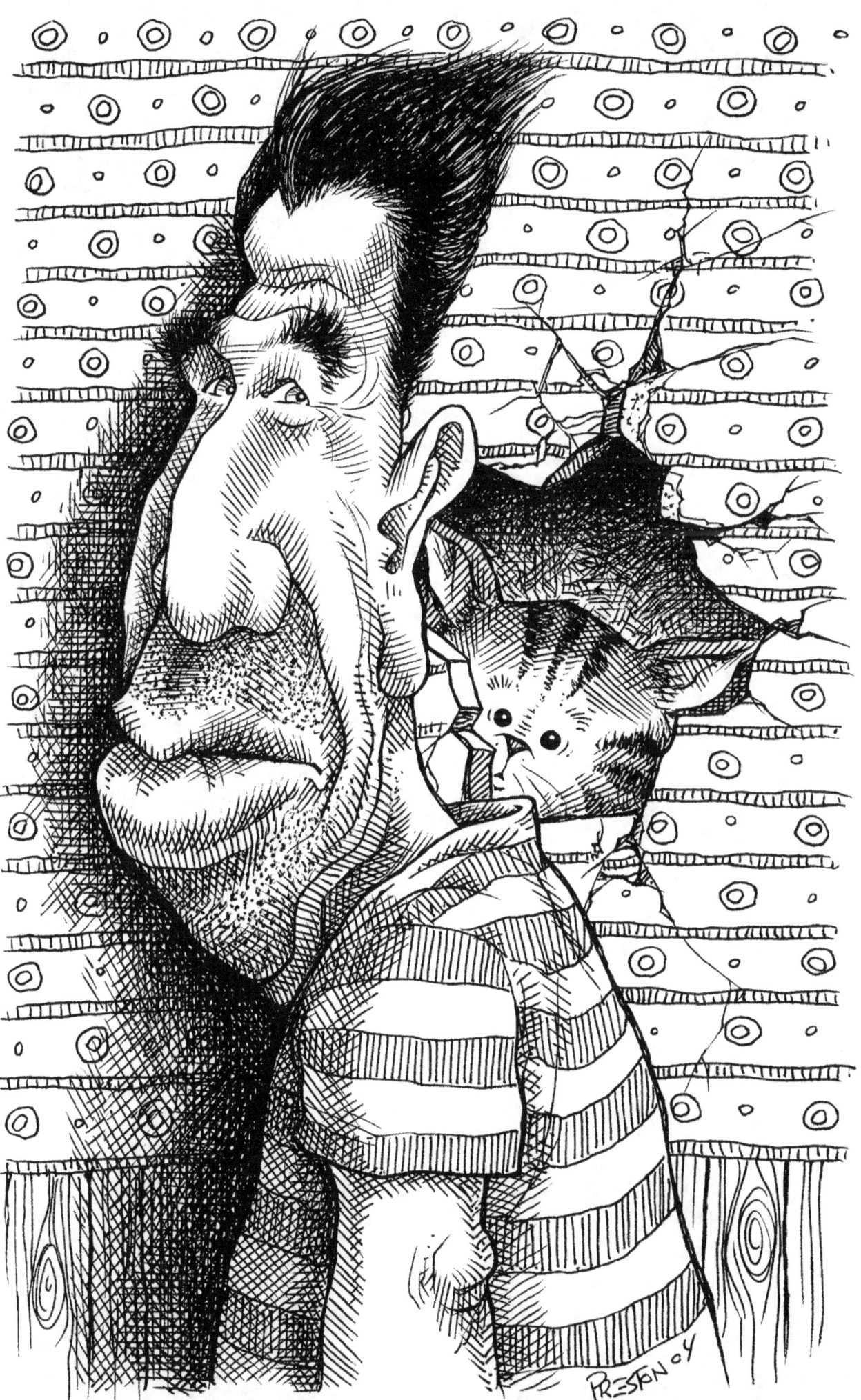

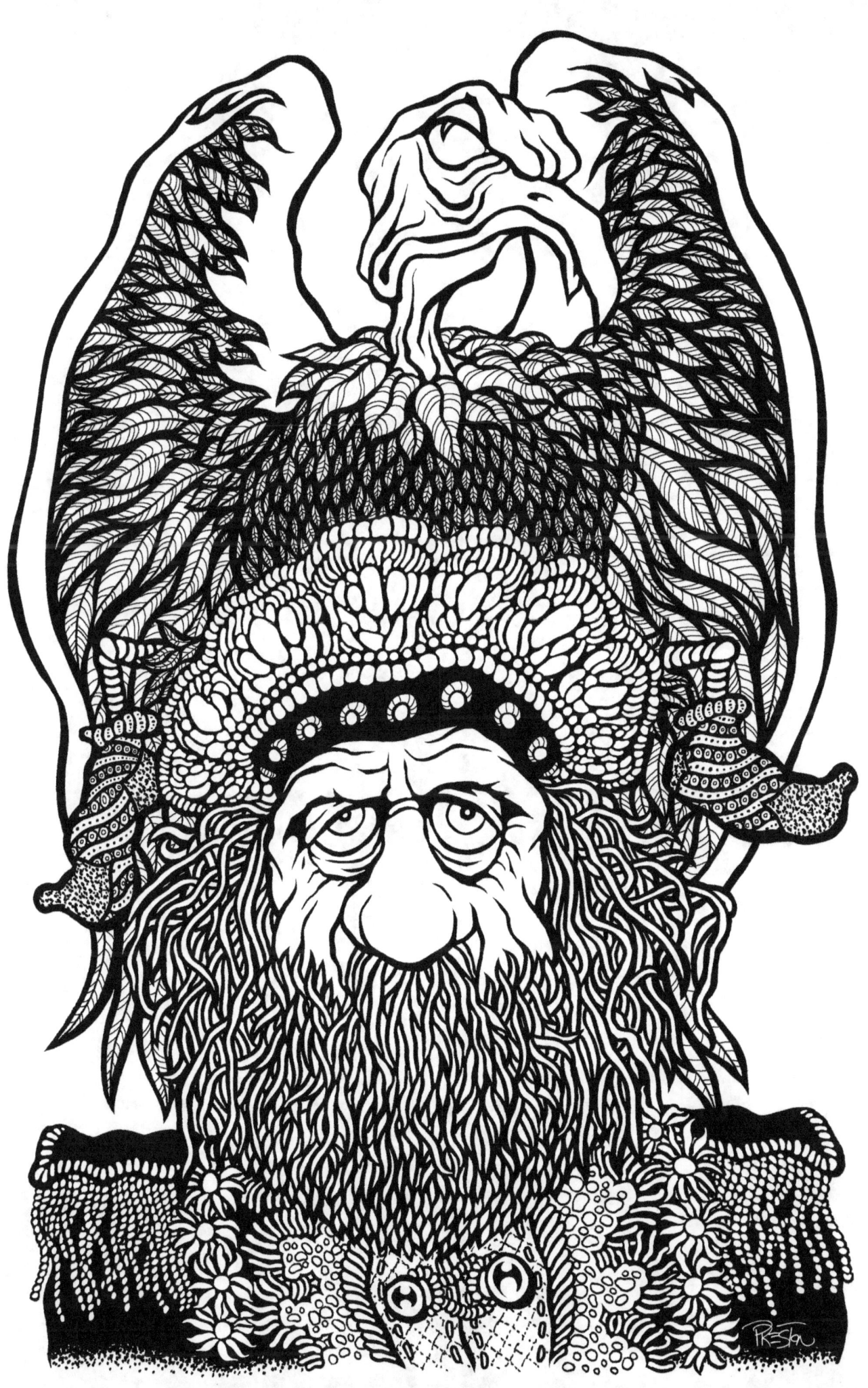

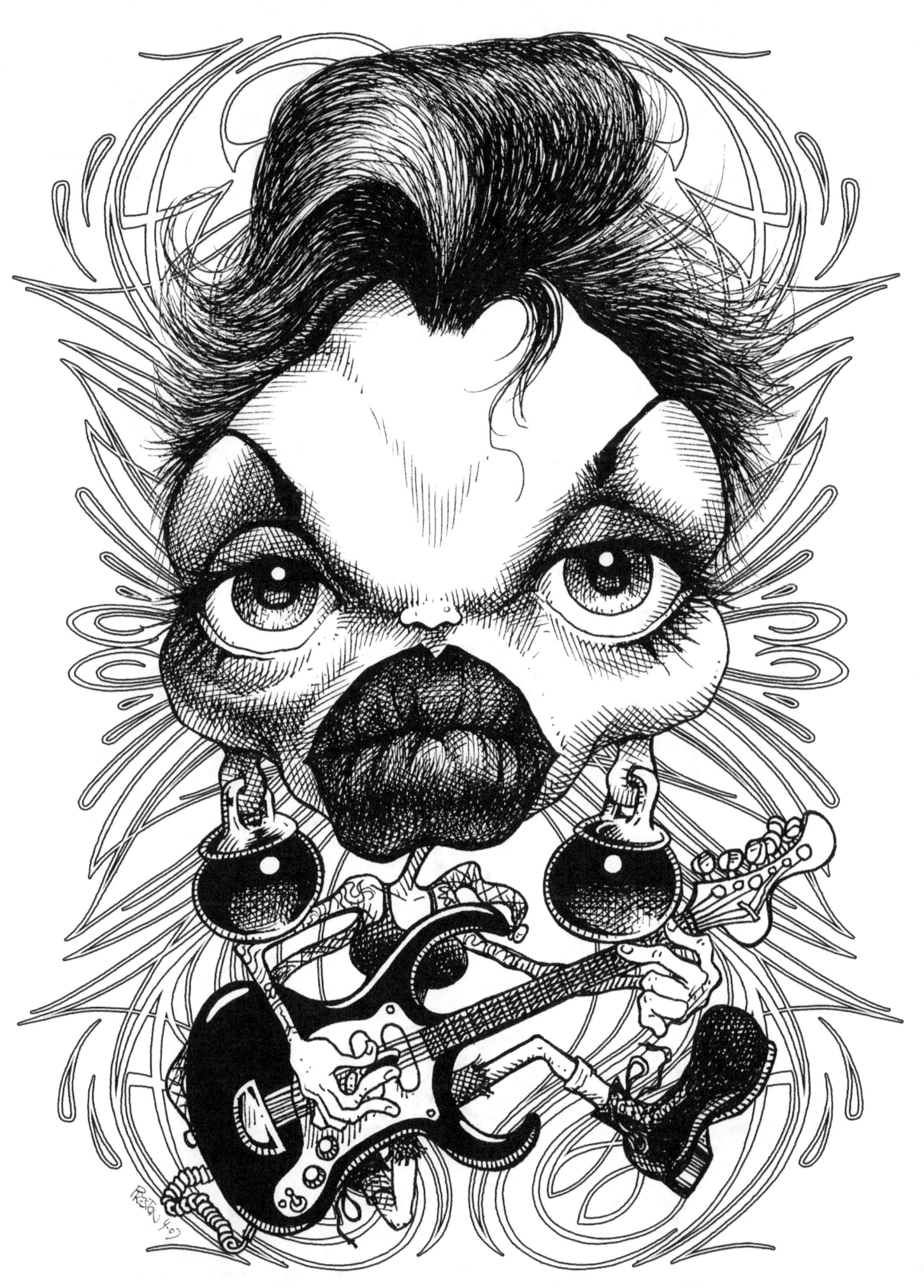

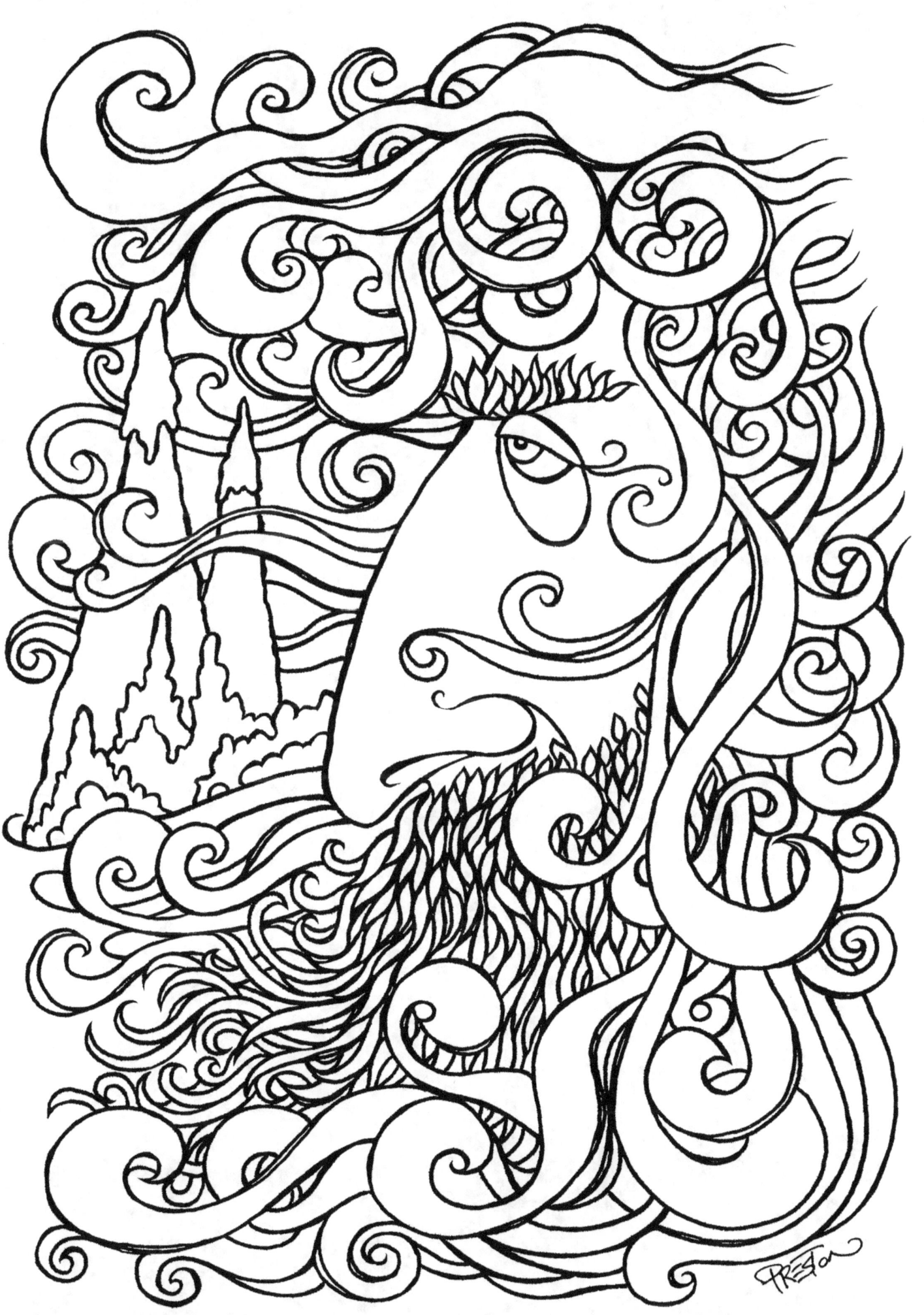

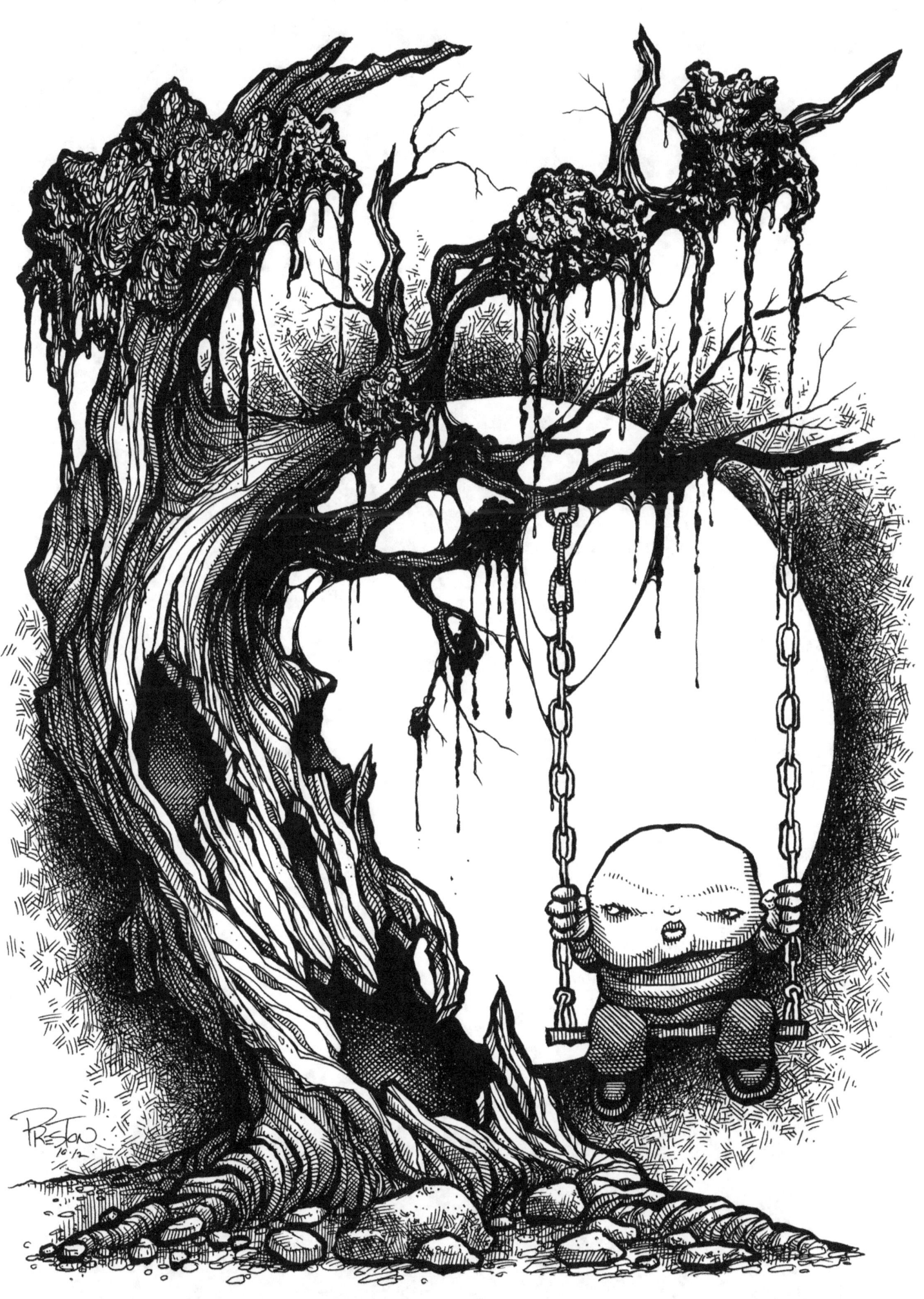

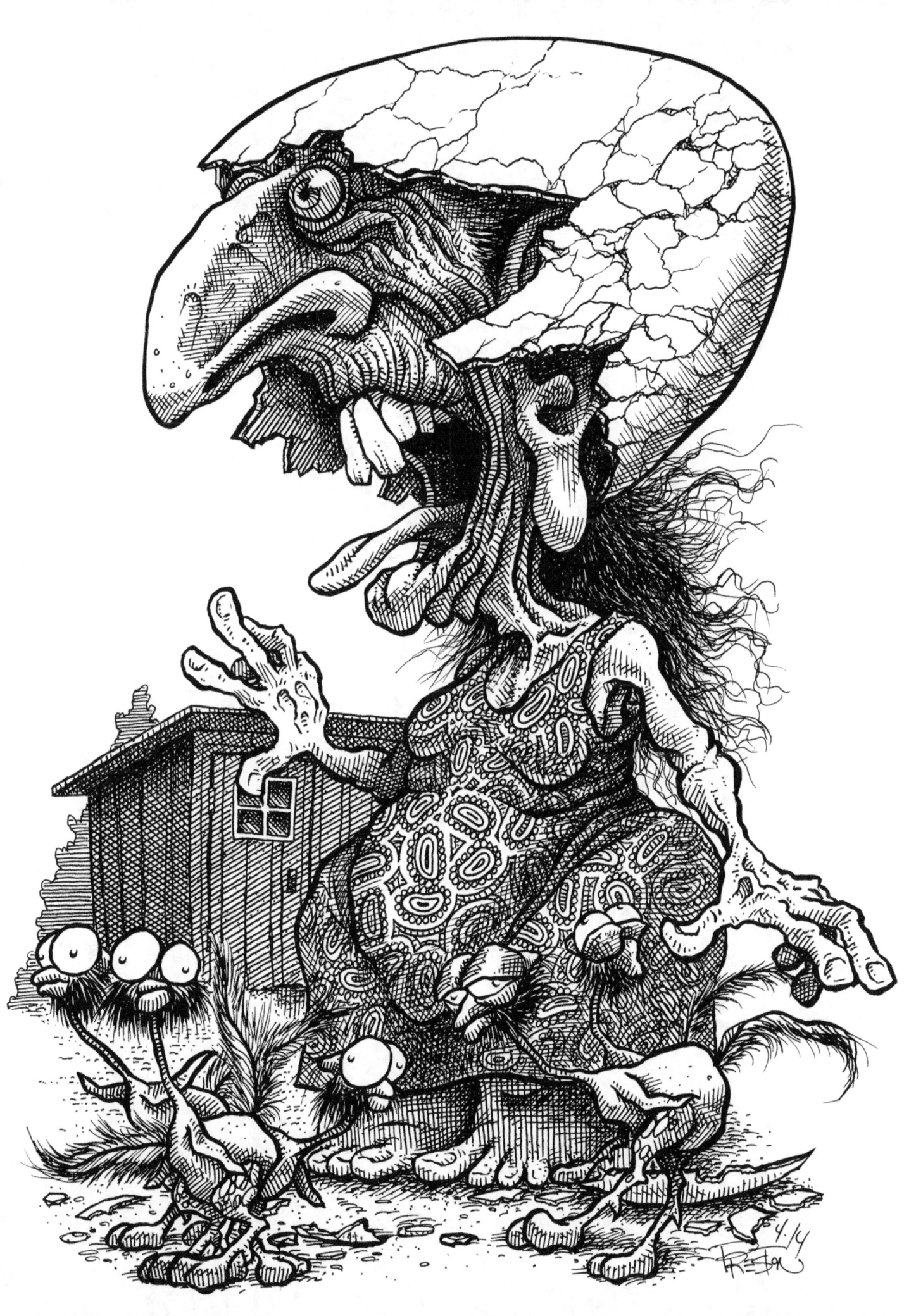

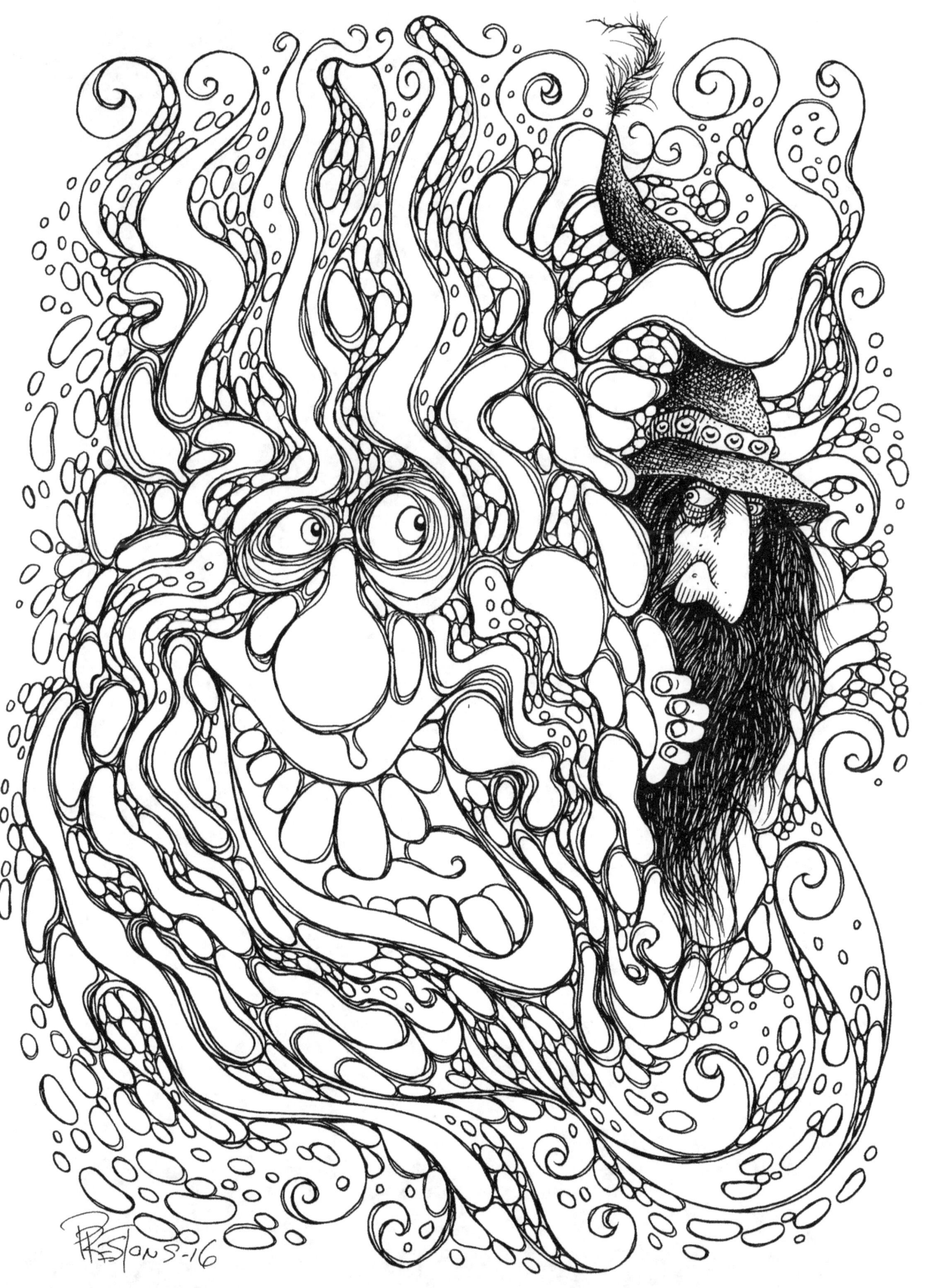

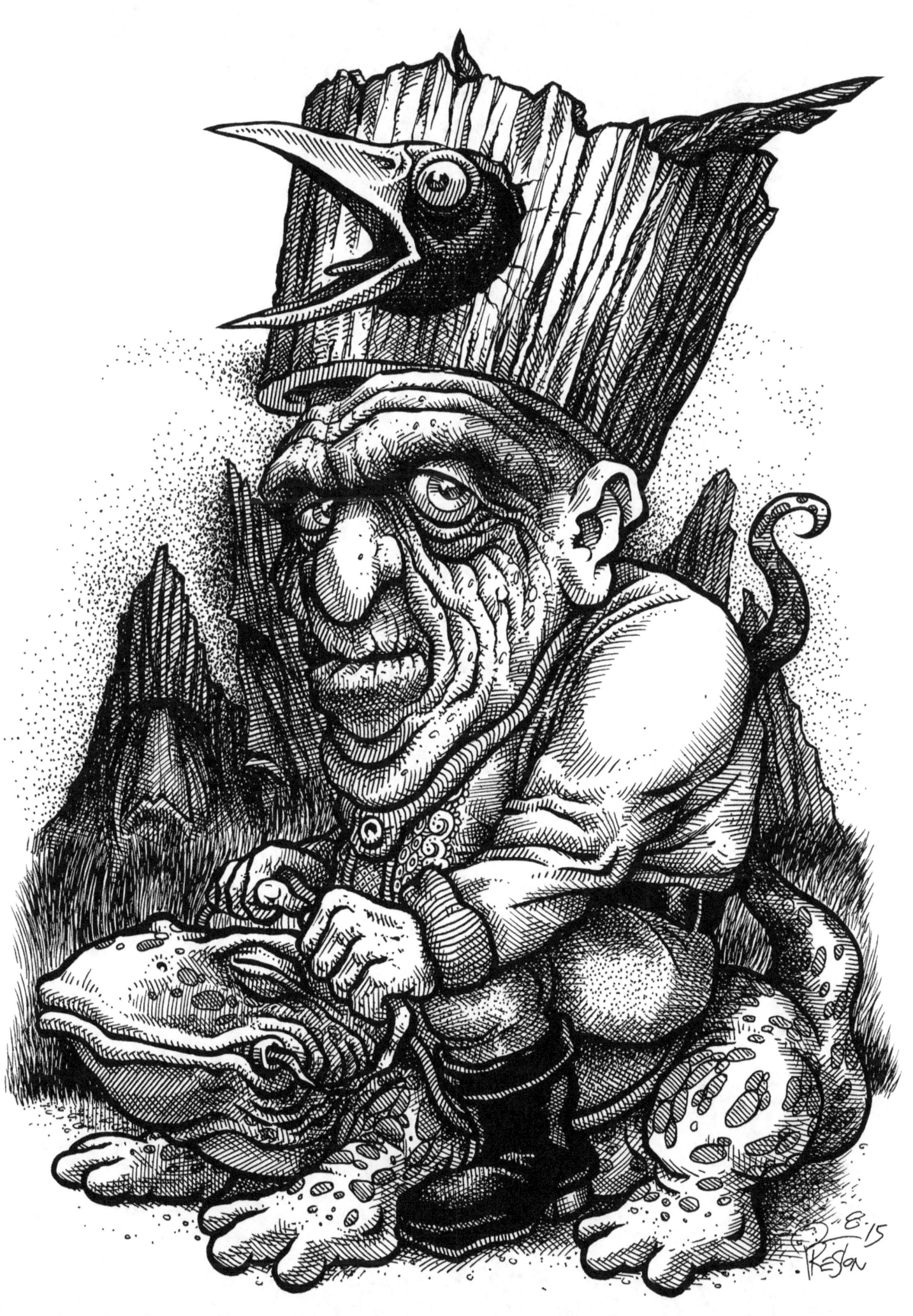

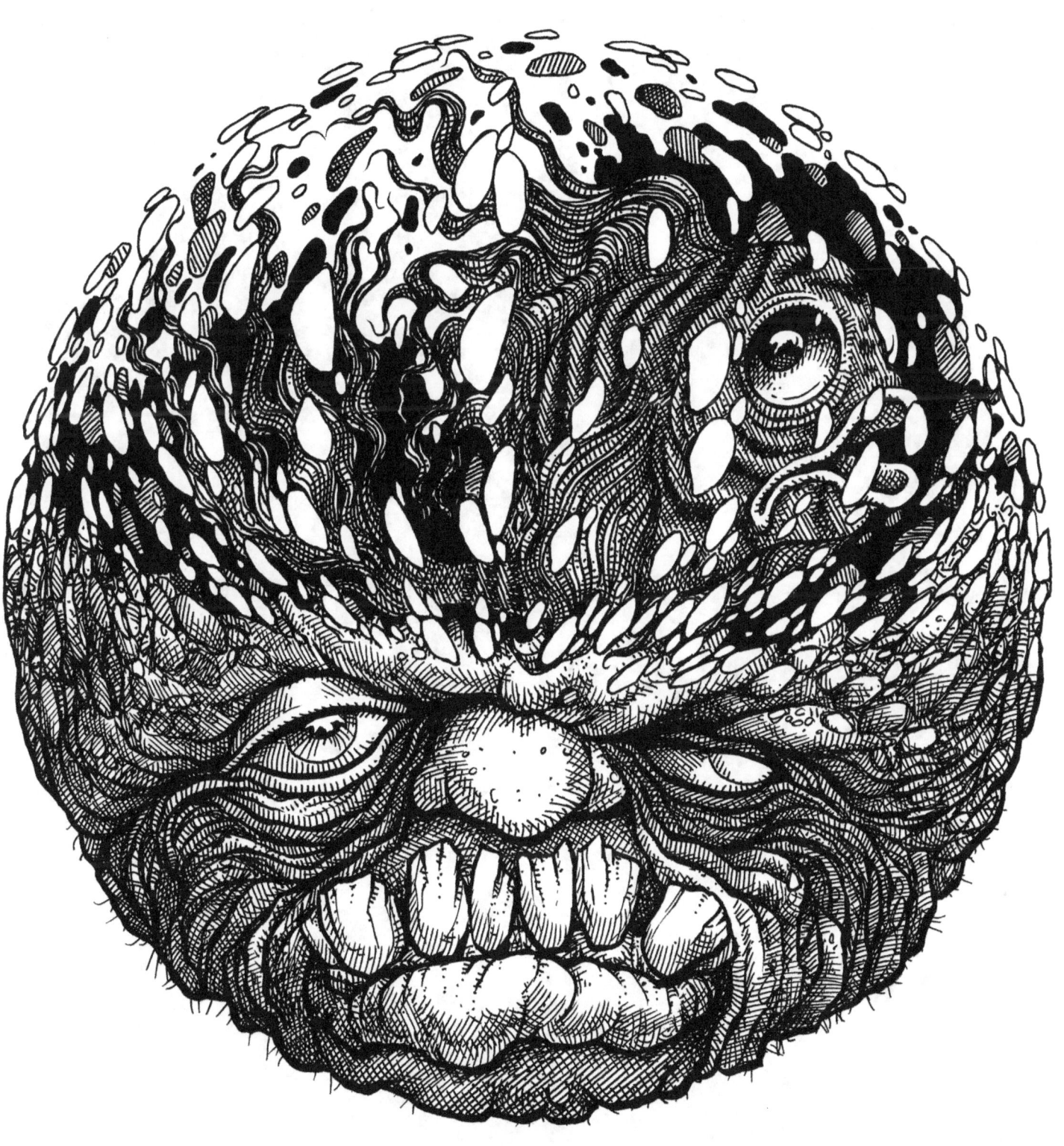

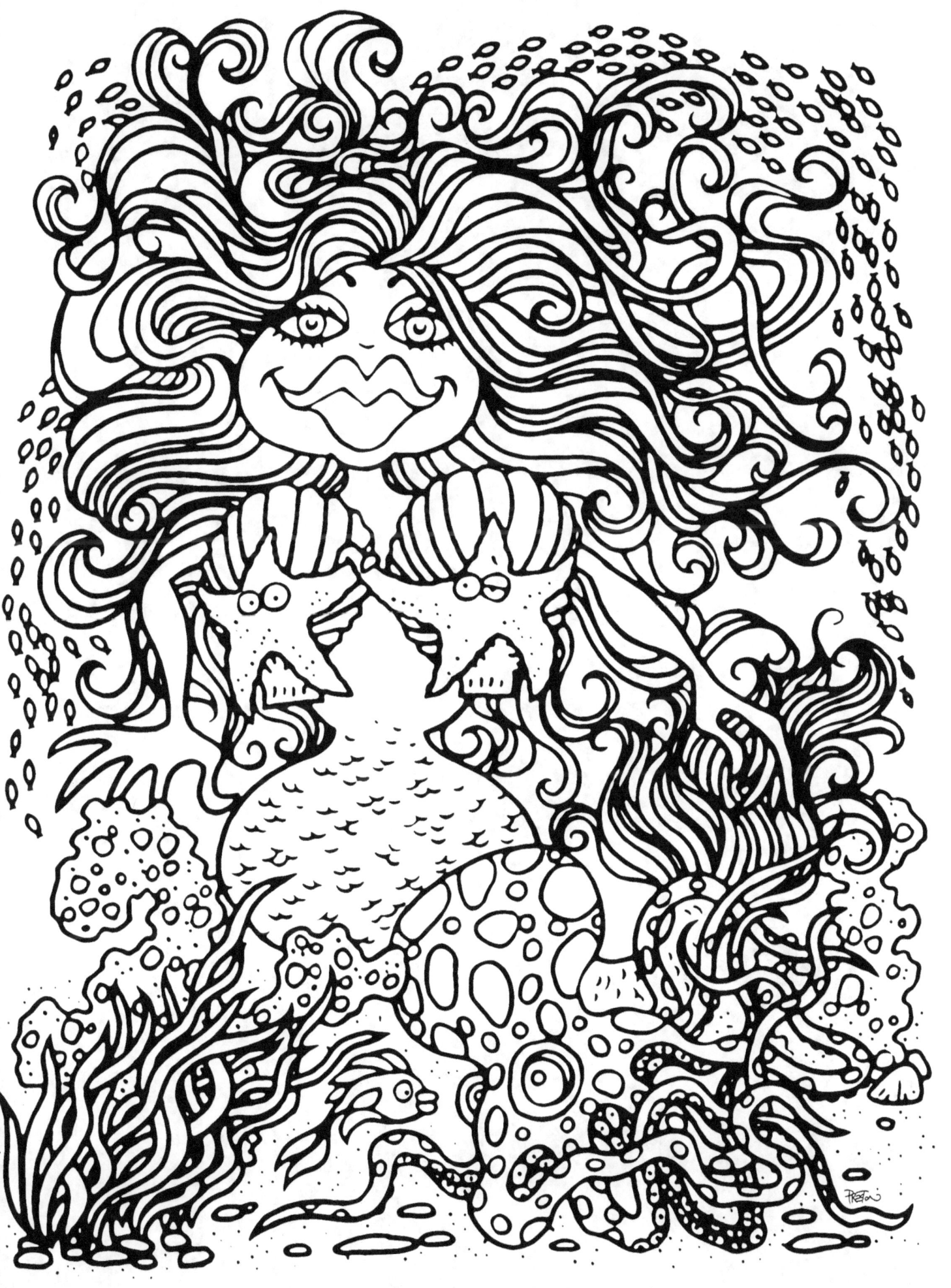

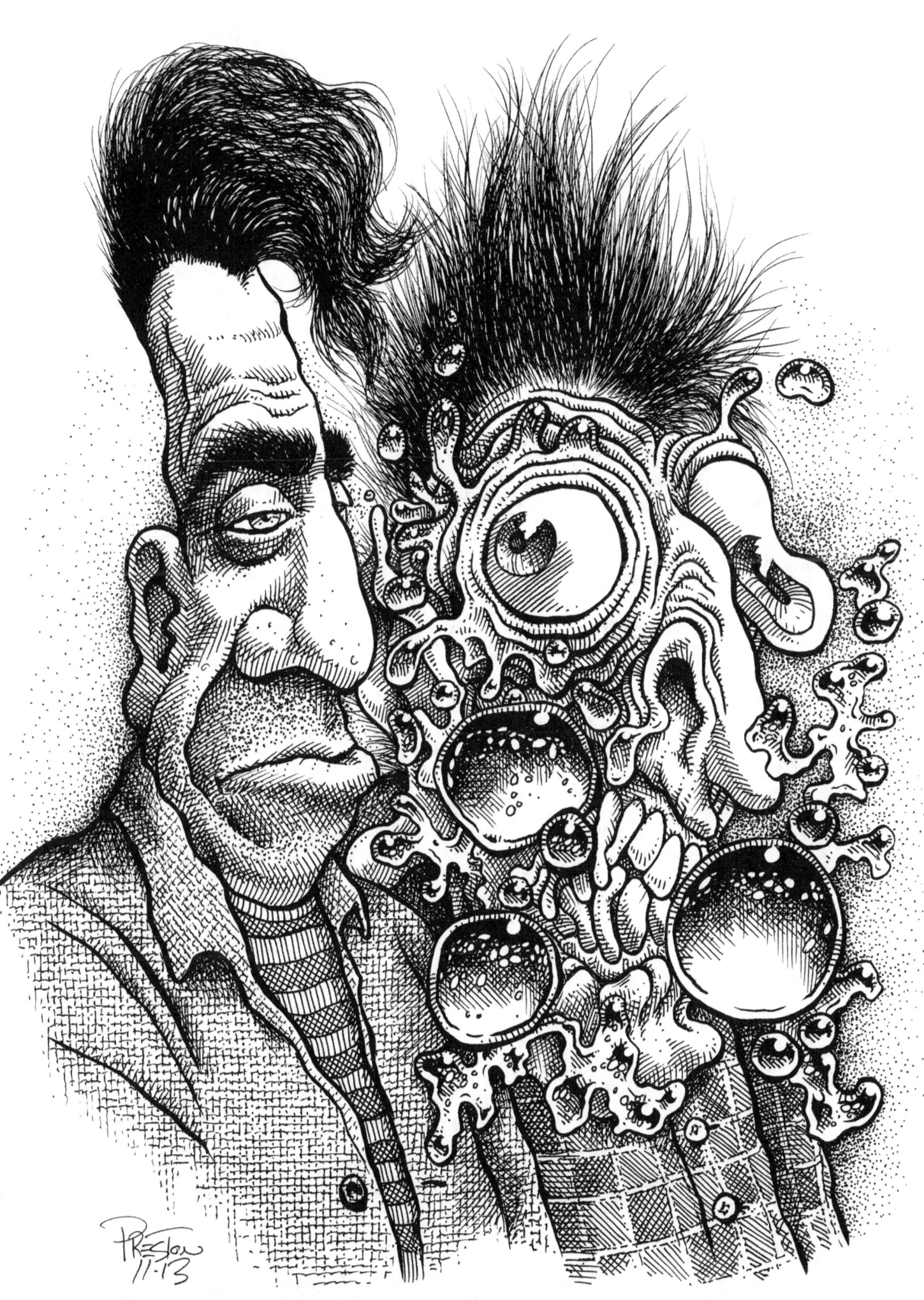

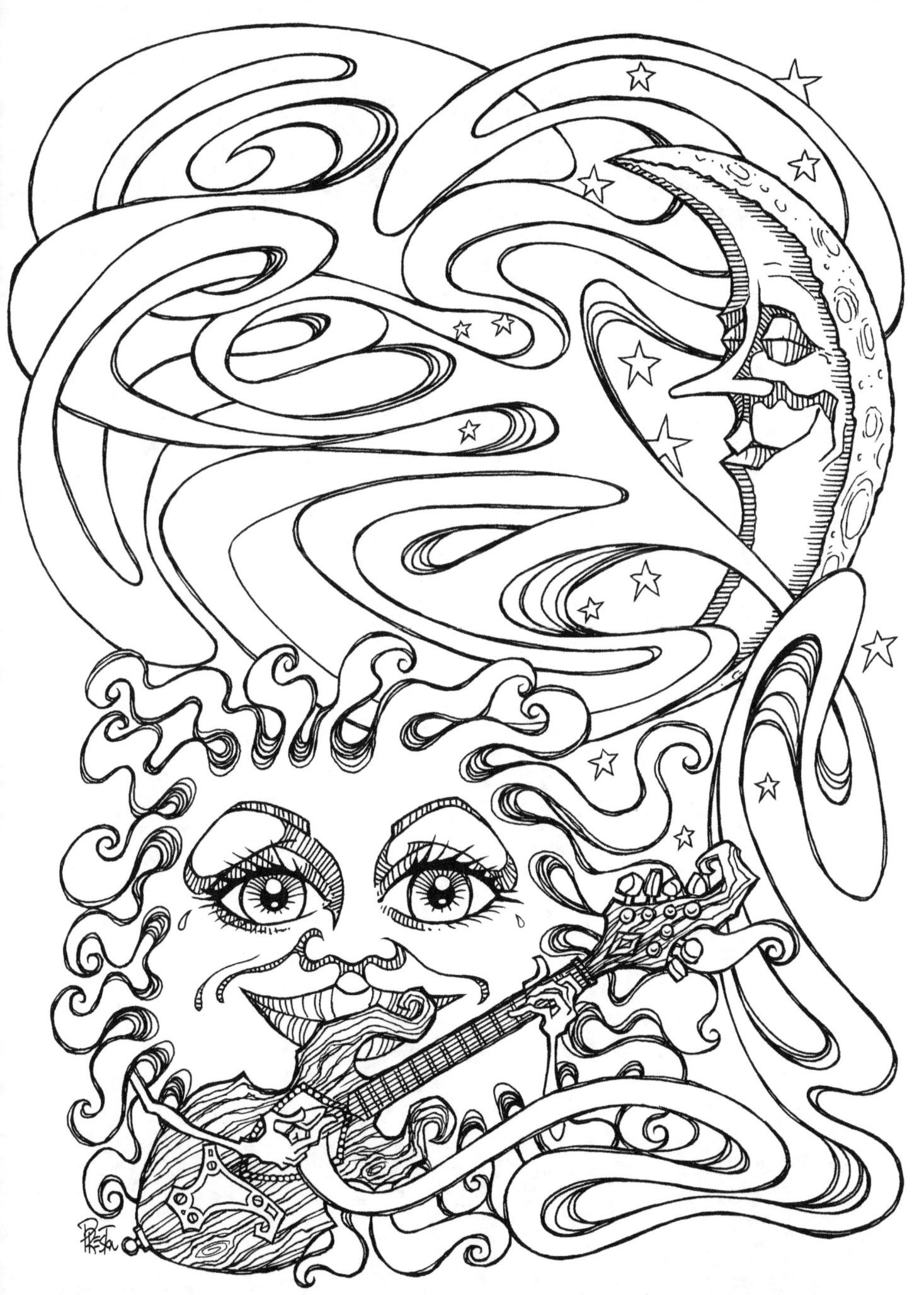

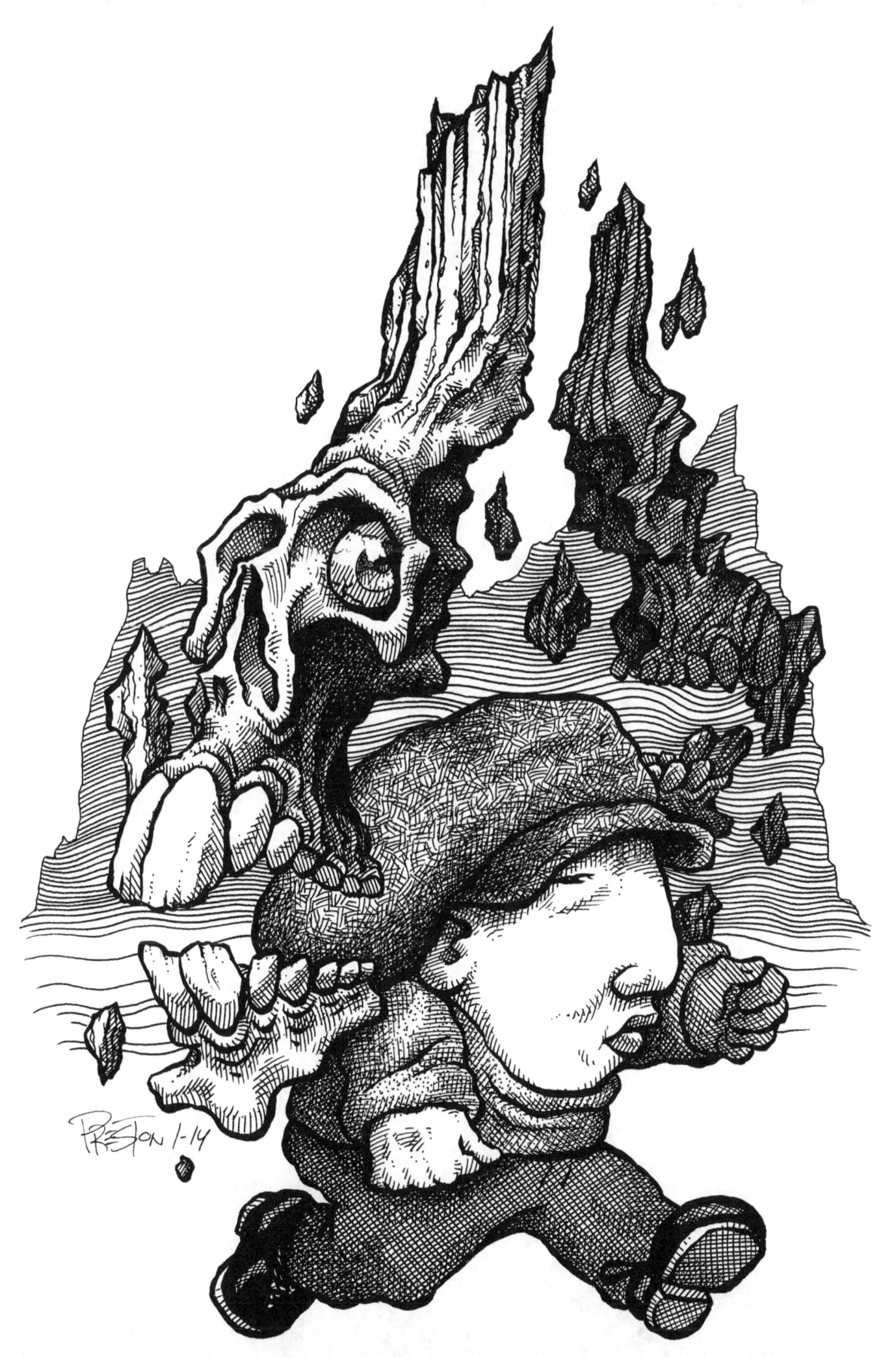

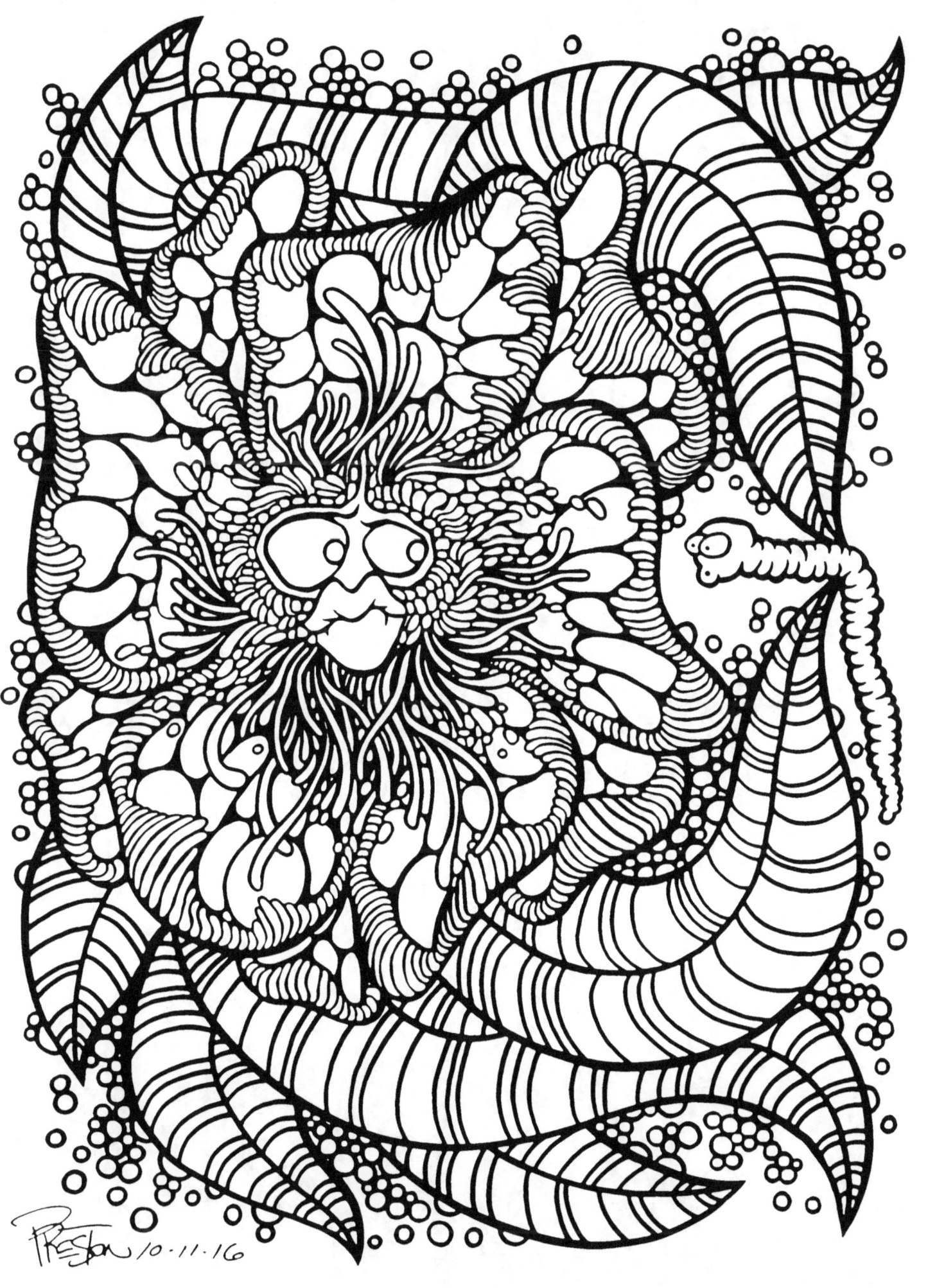

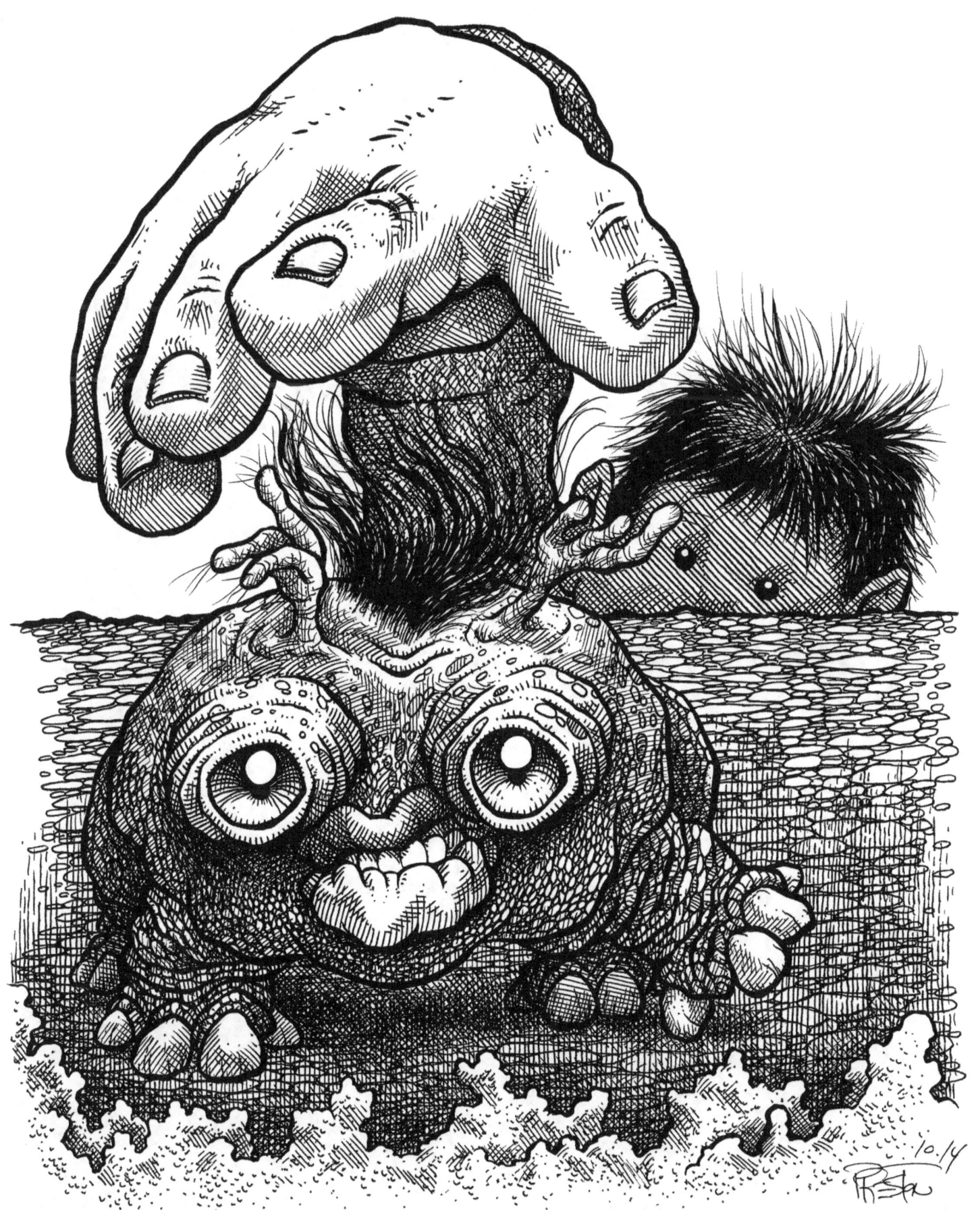

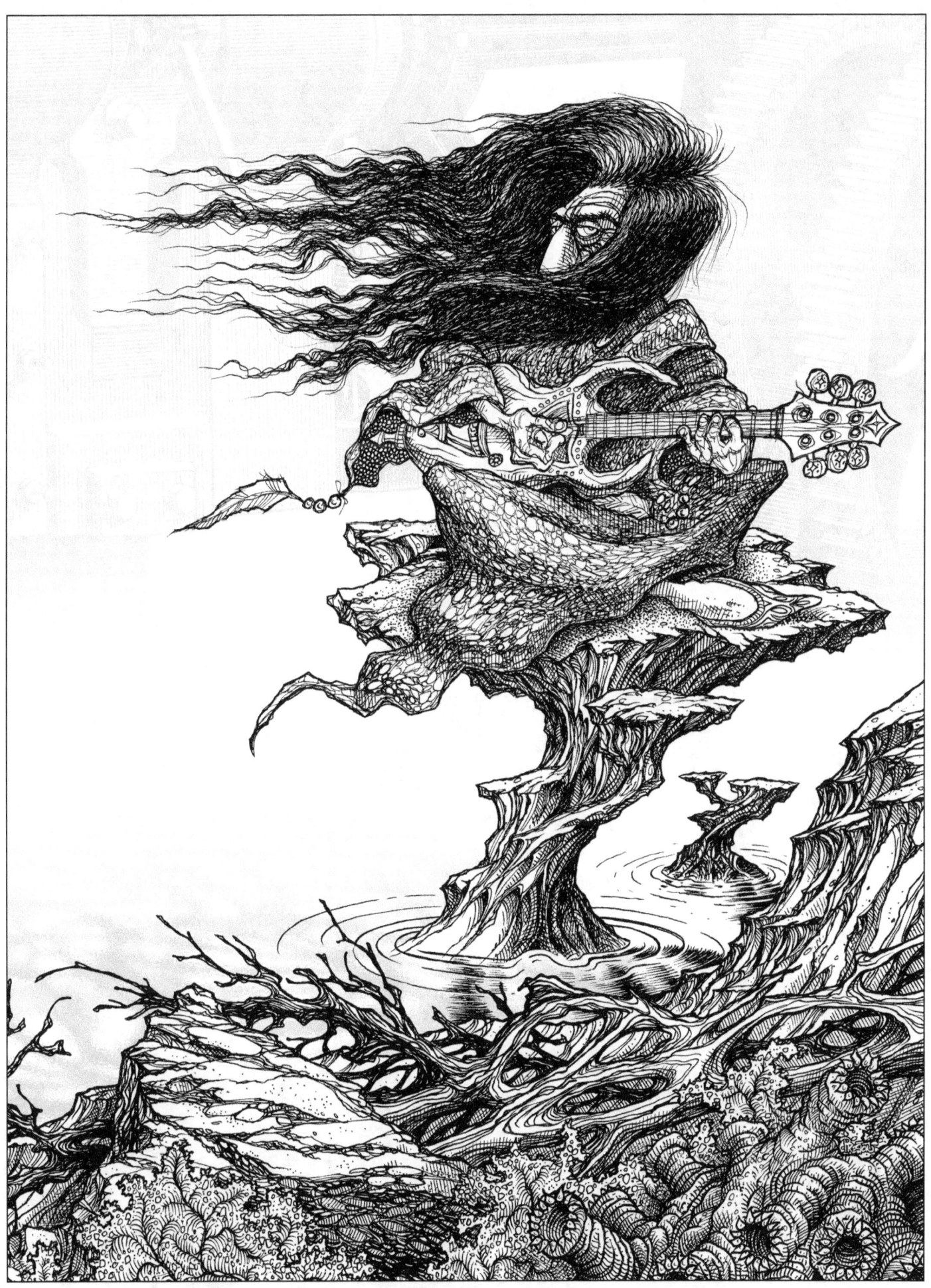

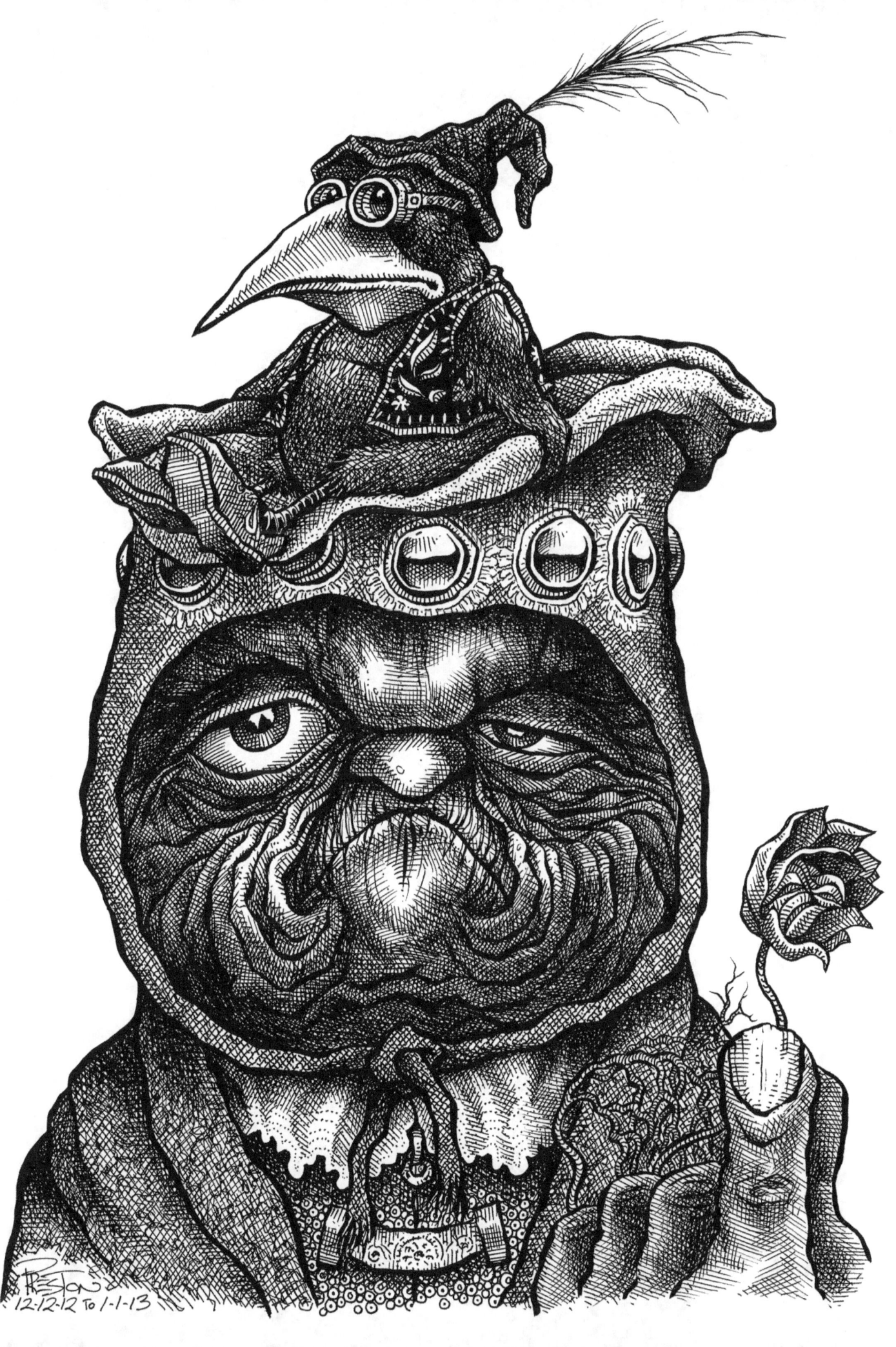

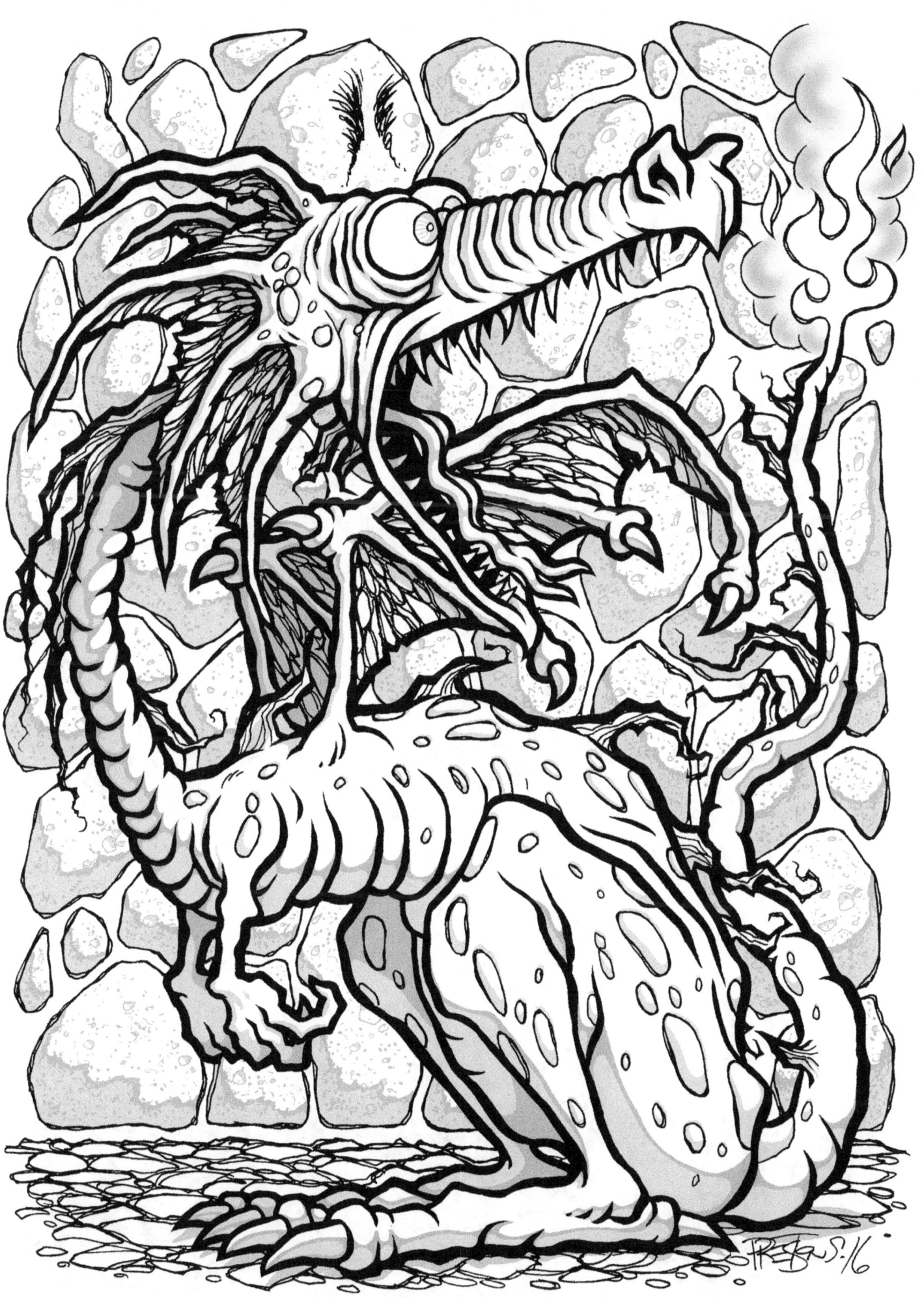

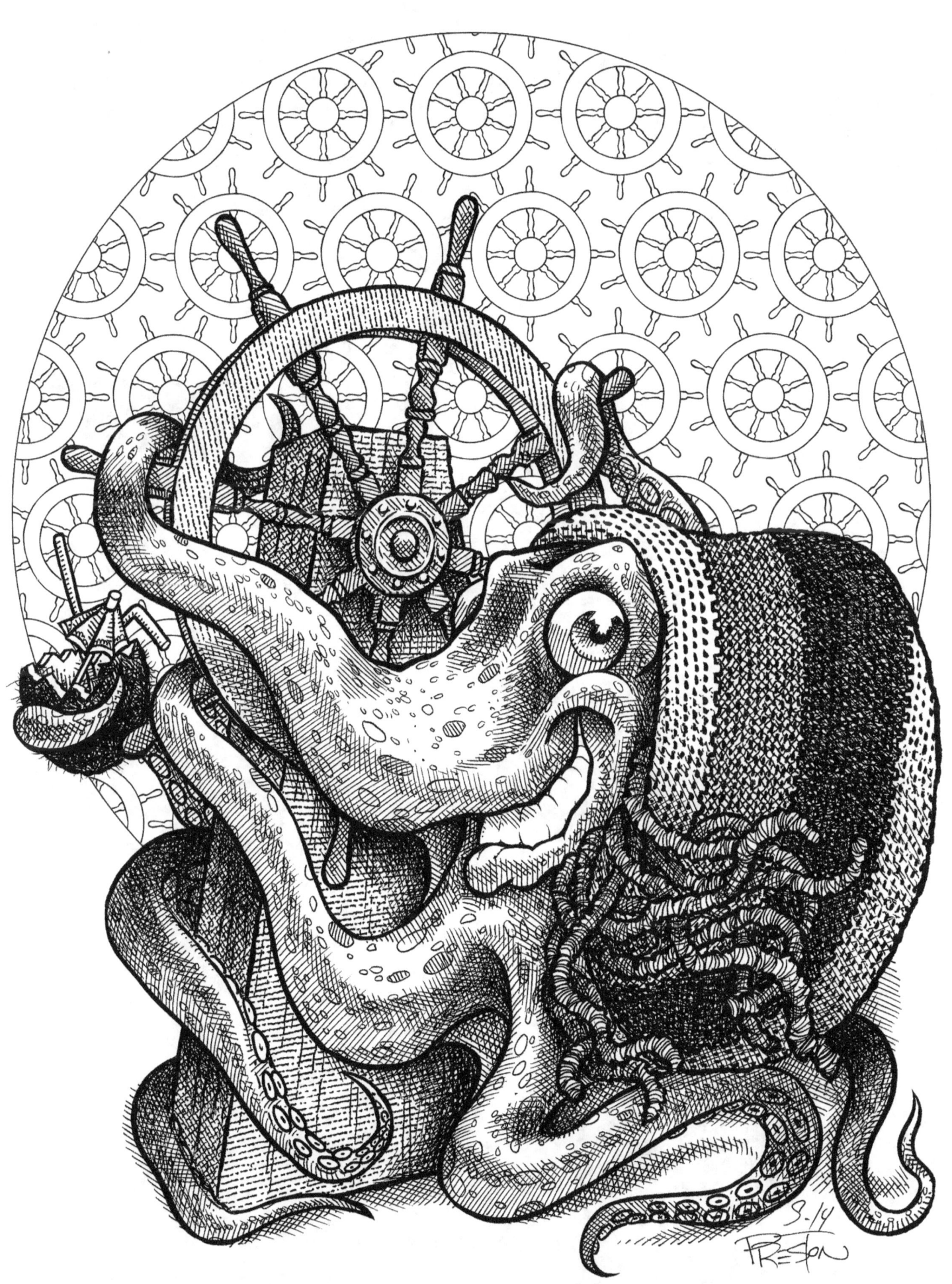

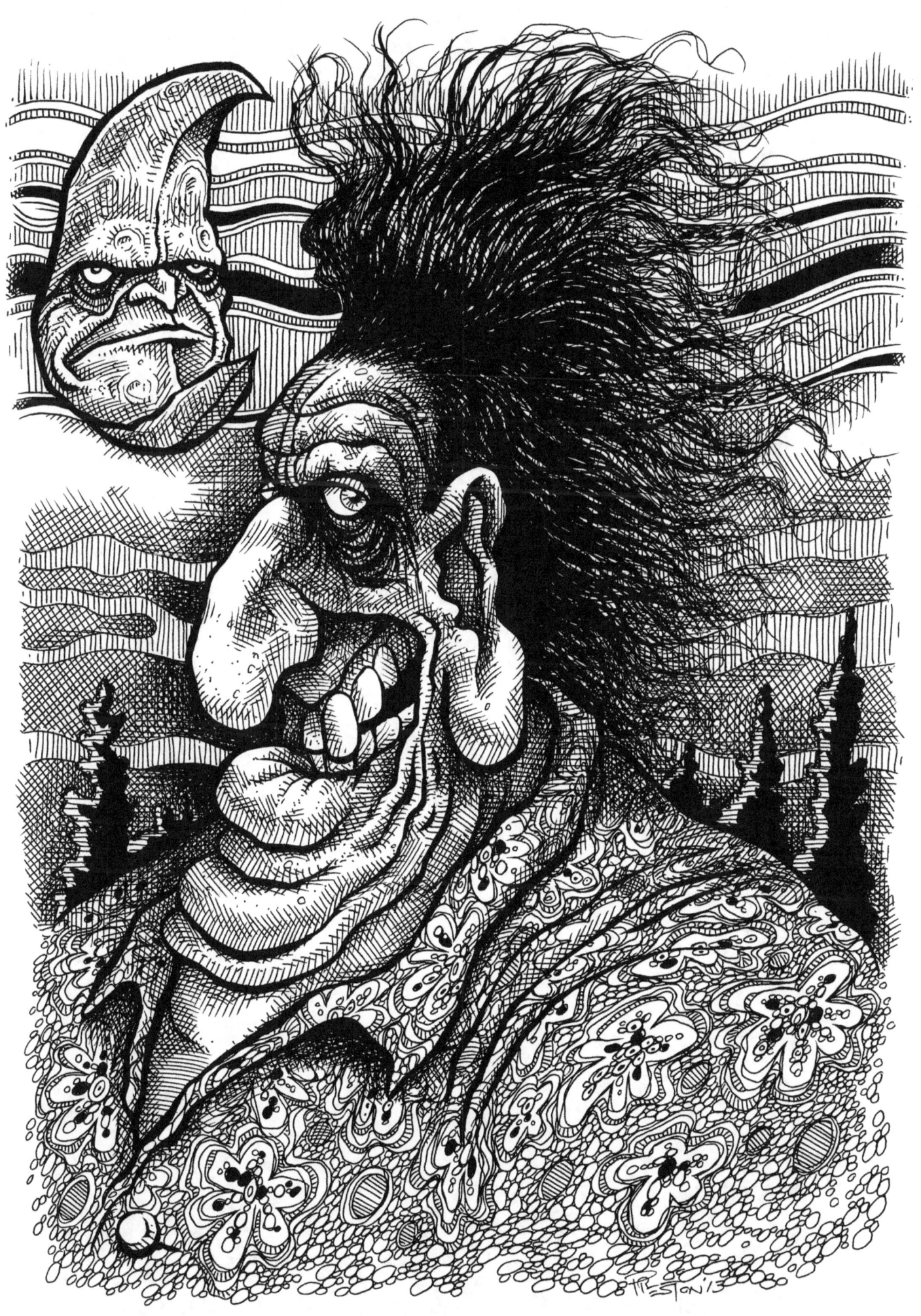

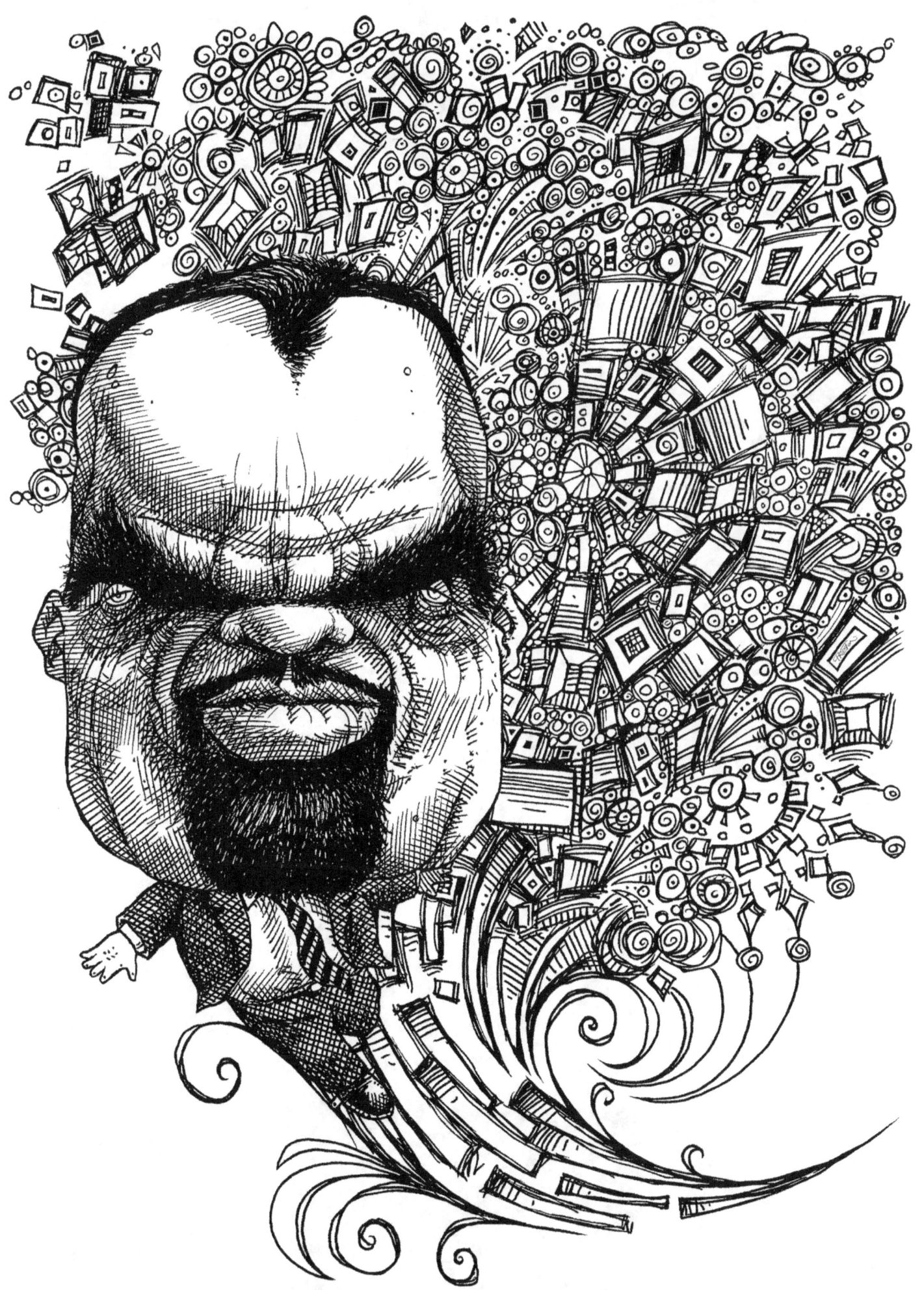

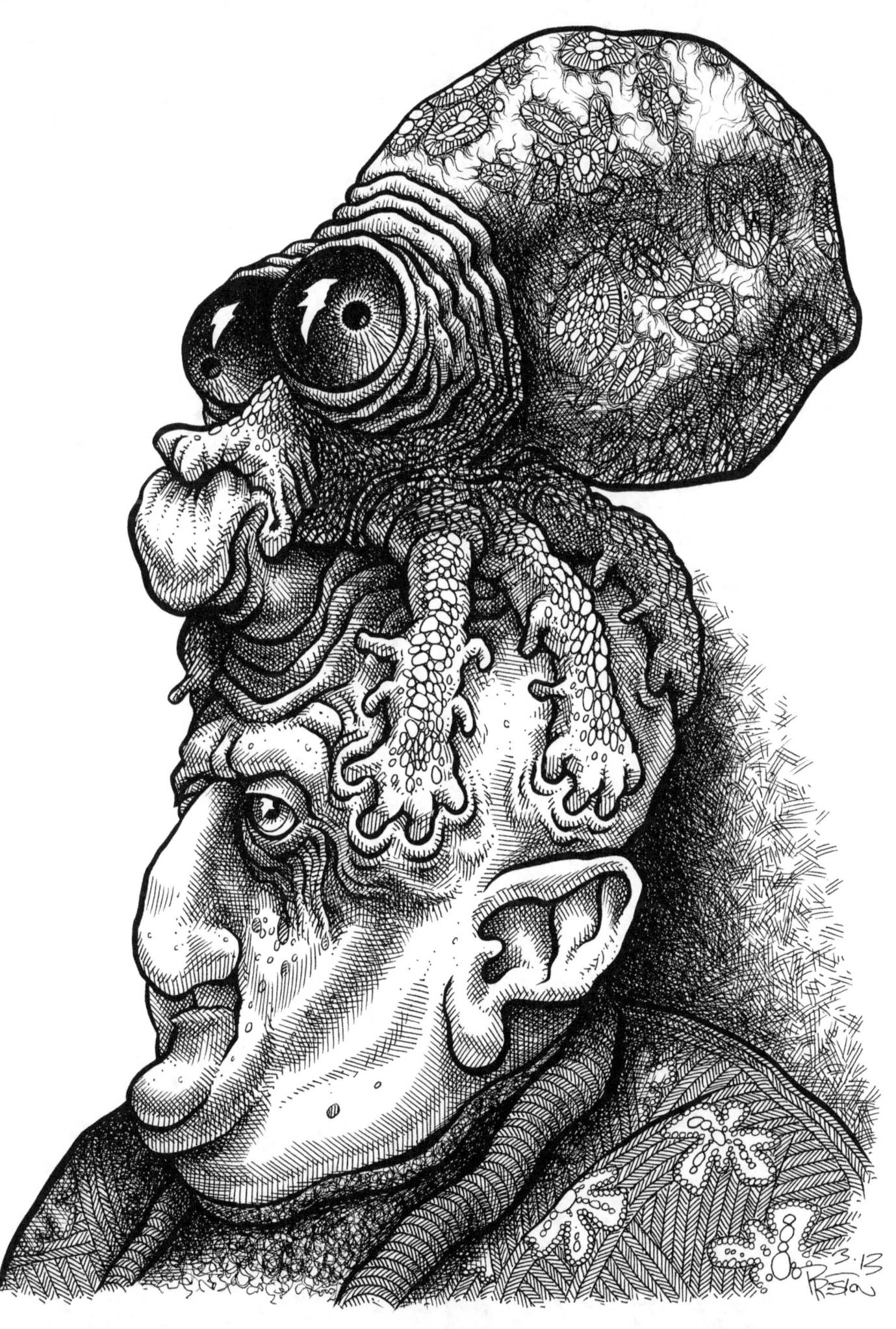

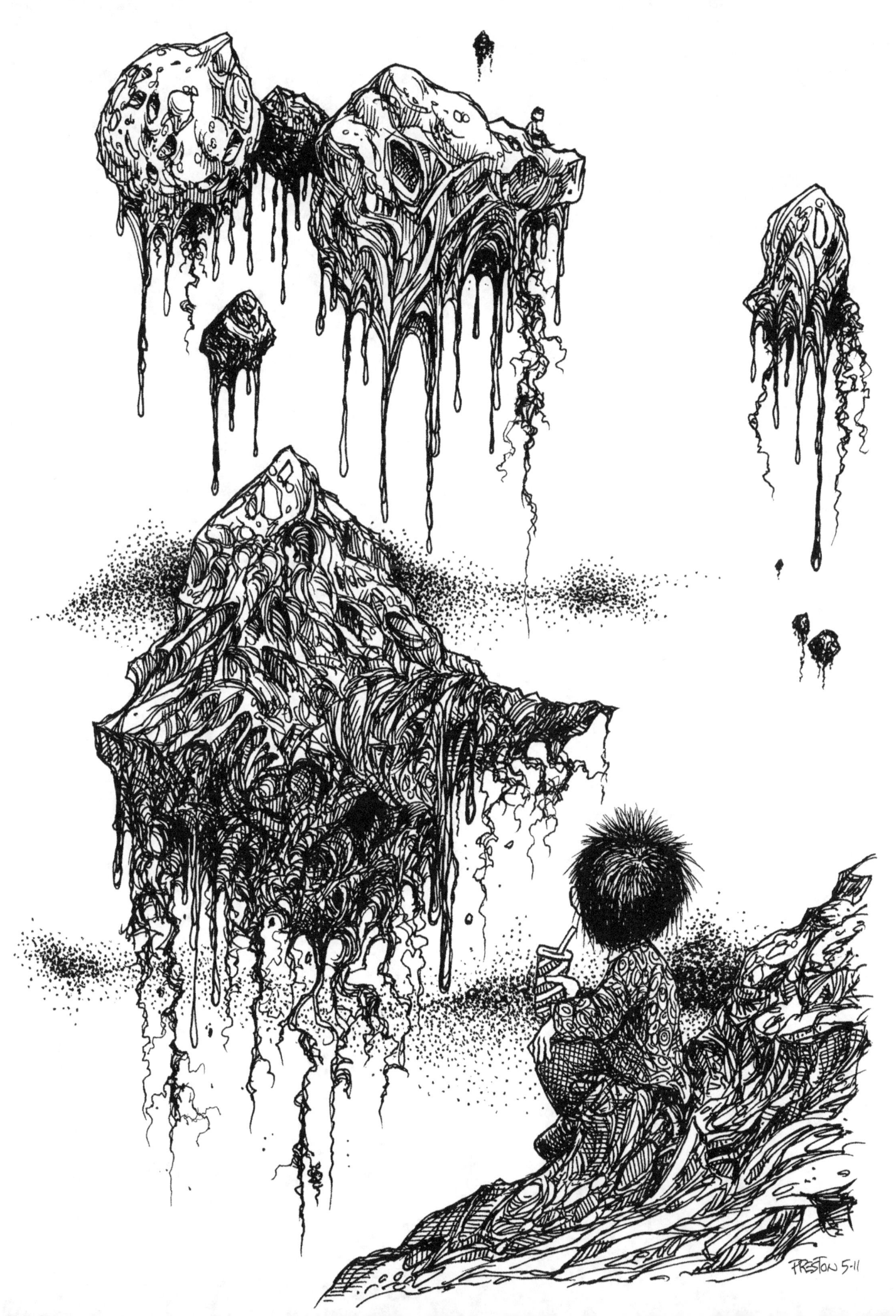

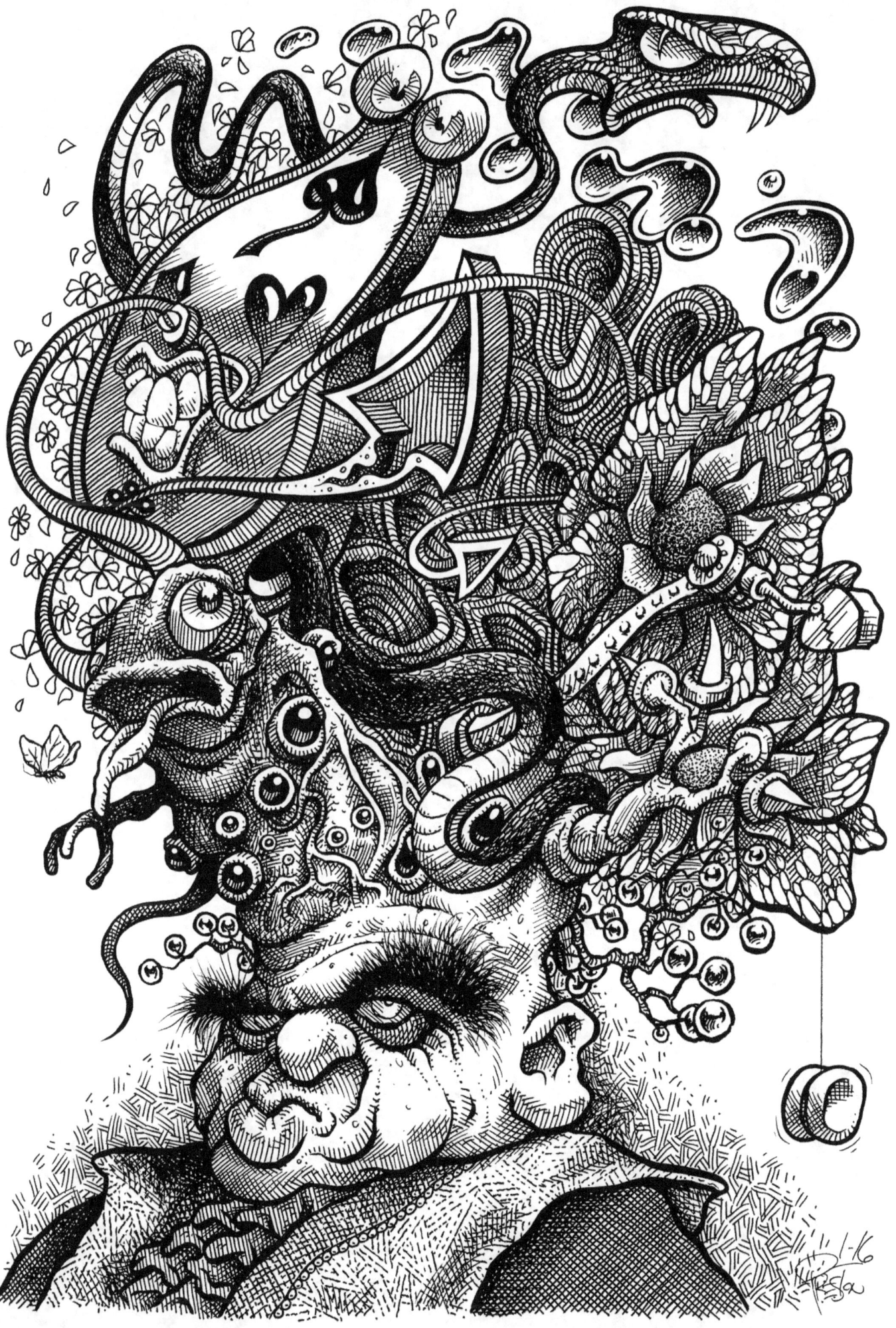

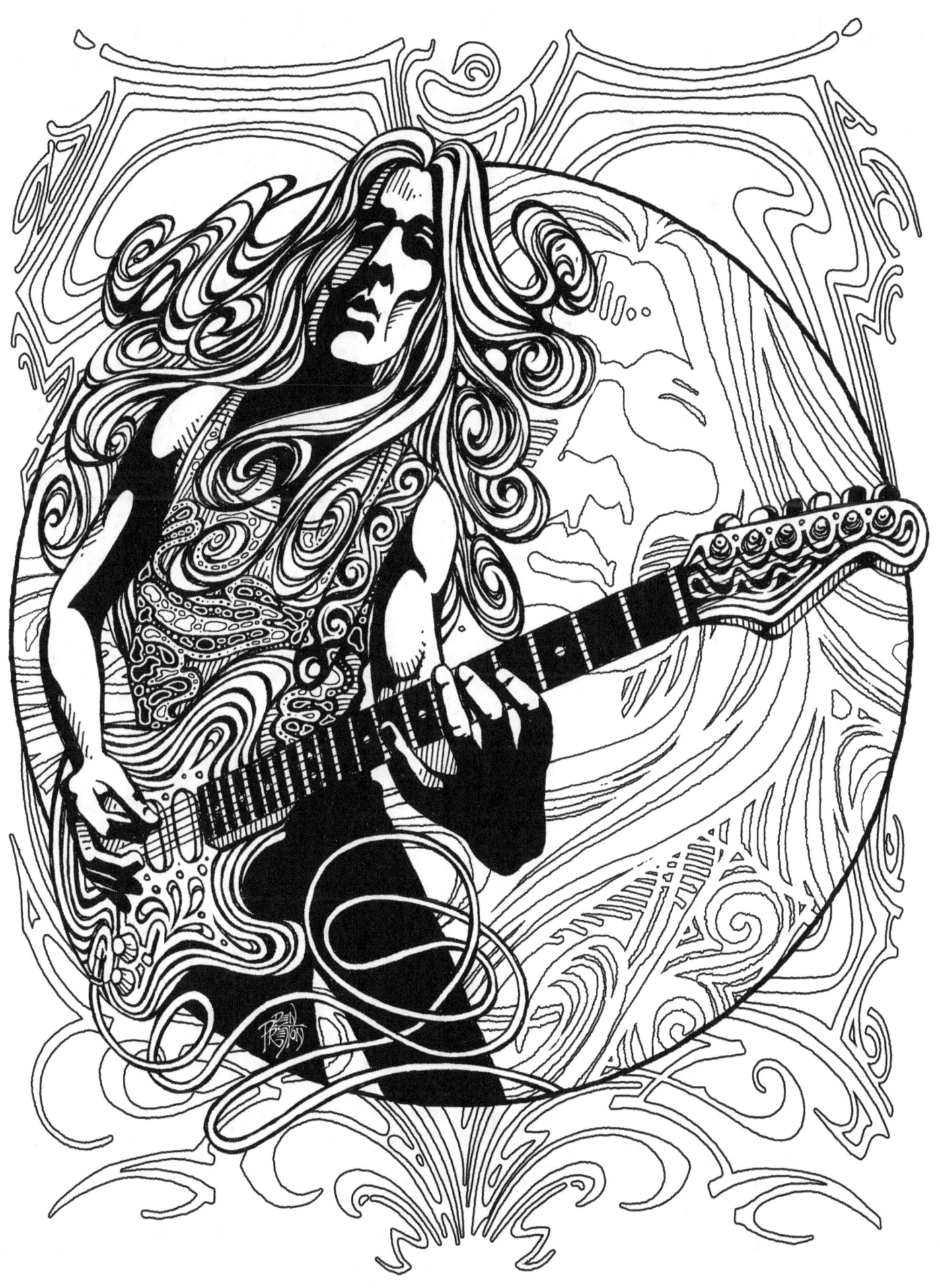

www.ingramcontent.com/pod-product-compliance
Lightning Source LLC
Chambersburg PA
CBHW080951170526
45158CB00008B/2444